Wicked WICHITA

Wicked WICHITA

JOE STUMPE

THE
History
PRESS

Published by The History Press
Charleston, SC
www.historypress.com

First published 2018

Manufactured in the United States

ISBN 9781467139106

Library of Congress Control Number: 2018945677

For Carrie.

CONTENTS

ACKNOWLEDGEMENTS

The author would like to thank the following people and organizations: Ann Hathaway Boll; "Hatman" Jack Kellogg; Jim Mason; Terry Rombeck; Jami Frazier Tracy and Eric Cale of the Wichita-Sedgwick County Historical Museum; Carole Branda of the Kansas African American Museum; Beccy Tanner and Jaime Green of the *Wichita Eagle*; Rex Riley of the Midwest Historical & Genealogical Society; Keith Wondra of Old Cowtown Museum; Jay Price of Wichita State University; Barb Myers and Mike Maxton of the "Wichita History from My Perspective" Facebook page; Wichita Public Library, especially staff of the Wulfmeyer Special Collections Center; the Augusta Historical Museum; the Wichita Police Department; Sedgwick County Sheriff's Office; U.S. Attorney's Office and U.S. District Court, District of Kansas; Wichita Bar Association; Great Plains Transportation Museum; and Rotary Jail Museum of Crawfordsville, Indiana.

WICKED WICHITA

One summer day in 1873, a dance hall girl named Kate Estelle donned men's clothing and slid into the mail car of a train leaving Wichita. Kate, a slender brunette with regular features and remarkable black eyes, was trying to escape her boyfriend, a hotheaded gambler and saloon owner named Joseph Lowe. But the city's first railroad depot—the Santa Fe, located across Douglas Avenue from where Union Station sits today—was a bustling place. Somebody apparently saw through Kate's disguise.

As Kate's train rolled into Emporia, some five hours to the east, a posse of police officers stood waiting. Lowe had telegrammed ahead, accusing Kate of stealing $700 from him—or about $14,000 in today's money. By then, Kate had tearfully convinced the train's mail agent that she was the real victim, having received numerous black eyes and other wrongs from Lowe back in Wichita. The officers allowed her to ride on to Atchison, another six hours' travel. Police greeted her there, too. Lowe had telegrammed an offer of $100 for her detention. But Atchison police sided with Kate, too, helping her get away before Lowe's own arrival by train the next morning.

The editor of the *Atchison Daily Champion* newspaper knew the makings of a juicy story when he saw one. "Wicked Wichita" began an article in his newspaper two days later. It referred to Lowe as "one of the most notorious characters in the west" (true) and gave his nickname in the region: "Rowdy Joe." Kate was a "rather pretty" but dissipated woman with her own nickname: "Rowdy Kate."

The Atchison newspaper's combination of "wicked" and "Wichita" appears to be the first time the two words were paired in print. It stuck. Over the next fifty years, the phrase was used more than two hundred times by newspapers across Kansas as they printed and reprinted stories about murders, thefts, gambling, prostitution, bootlegging, political corruption and other shady dealings in Wichita, according to a search of the newspaper database kept by the Kansas Historical Society.

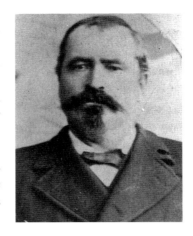

"Rowdy Joe" Lowe.

Some of the "Wicked Wichita" propaganda can undoubtedly be attributed to municipal jealousy. Wichita, although small in 1873, was on its way to becoming Kansas's largest city, surpassing many of the state's older settlements along the way. From larger cities such as Topeka and Atchison to smaller neighbors like El Dorado and Winfield, newspaper editors deployed the phrase to suggest that Wichita's prosperity was either undeserved or maybe even a result of unsavory activities. A desire to sell newspapers and a simple delight in alliteration were probably other factors: "Wicked Wichita" does roll off the tongue.

Wichita's own newspapers defended their home, accusing critics of sour grapes, hypocrisy and a host of less attractive traits ("Torpid Topeka" was one of their nicknames for the state capital). It's not like the rest of Kansas was exactly genteel. In Butler County to the immediate east, vigilantes executed eight suspected cattle thieves on questionable evidence. In Newton, twenty miles north, a single dance hall shootout left five men dead. But those were isolated incidents compared to the litany of felonies and misdemeanors committed in Wichita. The city's nickname stuck for a good reason: Wichita really was a pretty wicked place.

The story of Rowdy Kate and Rowdy Joe still had many chapters to go. But before returning to it, let's glance at Wichita in 1873, when their lovers' spat spilled onto the pages of the newspaper.

Wichita was then officially three years old, incorporated as a city in 1870. Settlers had pushed their way into the area for about a decade before that as the government moved American Indian tribes from the area. It was a frontier teeming with danger and opportunity. According to an early history of Sedgwick County, one of the area's first permanent white settlers, John Ross, went to hunt buffalo one day in the fall of 1860 and never came back. A search party made up of men from Butler County found all that was left of him—his head and one leg, still clad in a boot—and buried it under a pile of stones. It was assumed that Ross had been killed by Native Americans, some of whom still lived in the area and traded with the arriving settlers.

J.R. Mead, an early trader considered by many to be the father of Wichita, was in the killing business on a large scale, targeting the area's seemingly inexhaustible supply of buffalo. During one three-week period, he and two helpers killed 330 buffalo, harvesting 300 hides and 3,500 pounds of tallow (worth about $400 total back then), plus assorted elk, antelope and wolves. Mead alone slaughtered 35 buffalo in one two-hour period. More hunters, traders and farmers gradually entered the area, followed by businessmen and professionals whose names still adorn city streets, neighborhoods and buildings: Waterman, Kellogg, Hoover, Mathewson, Munger, Allison and Eaton.

Soldiers and a U.S. marshal were sometimes around, but nothing resembling law and order existed. Consider a story from that same early written history, attributed to a settler in Kechi, just north of Wichita. One night in 1869, the settler and his brother heard gunfire coming from a corner of their claim on the Little Arkansas River. Rushing from their tent, they found men camped with a herd of cattle from Texas. On the ground lay the body of a herder. He had gotten drunk in Wichita earlier that evening, taken out his knife and chased the outfit's cook around the fire several times. The cook took out his revolver and shot him dead. "As we had no law here at the time," the settler recalled, "no legal proceedings were instituted."

Historians rarely fail to note that one of 124 people to sign Wichita's incorporation papers—and the only woman to do so—was Catherine McCarty, mother of the notorious outlaw Billy the Kid. The young Billy, ten or eleven at the time, is not known to have broken the law in Wichita, although he wouldn't have lacked for role models.

In an 1870 election marked by irregularities, Wichita beat out Park City to be named the Sedgwick County seat. The city's first newspaper, the *Wichita Vidette*, hinted that votes might have been bought with liquor since "some

of the lads became a little hilarious at sundown. Where they obtained the vivifying elixir is a mystery, as all the saloons were kept rigidly closed during the entire day."

As an early example of the city's entrepreneurial spirit, four Wichita leaders rode out on their horses to bribe leaders of a Texas cattle drive headed for Park City to stop and spend their money in Wichita instead. On another business front, Ida May, the city's first madam, set up shop in Wichita. May migrated westward from Emporia with enough earnings to buy the town's first two-story house, on Main Street, which she turned into a brothel.

In the spring of 1871, a correspondent for the *Leavenworth Times* visited the young town. About eight to nine hundred people lived there, he noted, making it the largest settlement on the border with Indian Territory (the future Oklahoma) to the south. A steady stream of Texas cattlemen passed through town wearing broad-brimmed hats, spurs and belts big enough to hold a pair of six-shooters. There were fastidiously dressed easterners present, too, presumably scouting potential business deals. The latter stayed at the city's biggest hotel, the Harris House, located near the present site of the Occidental Building on Main Street. The Leavenworth correspondent described the Harris House as "a finer hotel in all its appointments, than [a visitor] will see in a town in the East of four or five times the size of Wichita." Sadly, the hotel's owner, John D. "Jack" Ledford, had been killed the week before the writer's visit, shot down in a wild gun battle with a U.S. marshal and posse of soldiers in broad daylight. "The public sympathy seems to be all on the side of Mr. Ledford," the writer noted.

Wichita entered a new era with the extension of the Santa Fe Railway in May 1872. More settlers poured in, and businesses and private homes "sprang up like mushrooms" to accommodate them, according to the early history. And Wichita became a full-blown cow town, with the first shipment of eighteen cattle cars rolling out in June 1872. Before that, cattle had been driven on past it to Abilene, Newton and other points north.

The Leavenworth correspondent who'd visited Wichita a year before termed it a gay and lively place. A correspondent from the *Kansas City Journal*, who arrived in 1873, found that atmosphere had been replaced by

"bacchanalian revelry." After dark, the city underwent a transformation as the more conservative portion of the population closed up shop and the Texas cowboys took over. "Brilliantly lighted saloons" threw open their doors, beyond which "gaily attired females" played piano, smiled and sweetly called to passing cowboys.

The correspondent visited a burlesque theater described as a dimly lit pine shanty with a small stage and six small lamps as footlights. From there, he ventured to a gambling hall called Keno Corner at the intersection of Douglas and Main (where Intrust Bank's main branch sits today) in which five-card monte, faro, roulette, poker and other games were played. A brass band from Kansas City played all night as "Texans and Mexicans" recklessly threw their money away "without stint or hesitation." Signs posted on the city's border advised, "Everything goes in Wichita. Leave your revolvers at police headquarters and get a check [receipt]. Carrying concealed weapons strictly prohibited."

This brings us back to Rowdy Joe and Rowdy Kate, who arrived in Wichita the same year as the railroad. The two Illinois natives had already raised a good bit of hell in Kansas. In 1869, authorities accused Lowe of drugging and robbing a man in Ellsworth, Kansas, another cattle town where he and Kate ran a bawdy house. Lowe was in his mid-twenties at the time and Kate still a teenager. By 1871, the couple had moved to Newton, just twenty miles north of Wichita. Lowe also ran a brothel there, catering to clients who spent their nights "drinking, tippling, dancing, whoring and misbehaving themselves."

During one dance at Lowe's place there, a stranger made advances to Kate. When she resisted, Lowe slapped her for insulting the man. Another man named Sweet, seeing his opening, fed drinks to Kate and took her to spend the night elsewhere. Lowe showed up the next morning. Sweet pulled a revolver, but Lowe fired two shots into him that proved fatal. Lowe immediately turned himself in to the sheriff, claiming that Sweet had threatened his life, and was acquitted a few days later.

The gruff Lowe made an impression on people. He was over average height for the time, square-shouldered, well fed and nattily attired thanks to his lucrative career. He had black hair, a swarthy complexion and a heavy

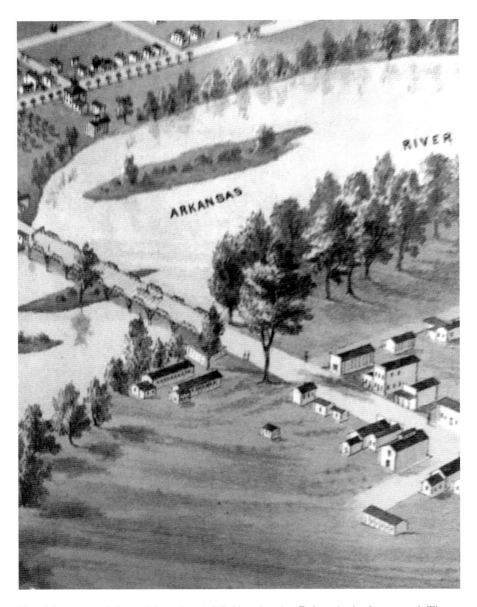

Detail from an artist's rendition of early Wichita, showing Delano in the foreground. The rival dancehalls of "Rowdy Joe" Lowe and E.T. "Red" Beard sat near the river. *Old Cowtown Museum.*

black mustache. A correspondent from the *Topeka Commonwealth* newspaper who toured Wichita in 1872 devoted far more space to "Rowdy Joe" and his "notorious dance hall" than to any other feature of Wichita. Lowe's dance hall was actually outside city limits at the time, just across the Arkansas River in what was called West Wichita or Delano, where the ban on concealed weapons did not apply. Cattle drovers were the main patrons, although all classes of society visited, if only from curiosity.

The saloon averaged more than $100 in drink sales a night (nearly $1,900 in today's money—a lot of curiosity). Dances were free, but the men were expected to buy drinks for Kate and her colleagues after each dance. Other services were also available. The going rate seems to have been a dollar a session. Texans with huge spurs on their boots and sombreros on their heads danced alongside gentlemen from back east, all taking their turns with Lowe's "painted and jeweled courtesans." Gamblers played poker in a corner.

Lowe served as his own bouncer. Few were inclined to pick a fight with him, but one customer who did suffered a severe pistol whipping. The Topeka newspaper correspondent considered Lowe a "singular personage" who had experienced "about as much roughness as any other man" on the frontier but who was not bad at his core. There must be, the writer concluded, "many men passing in society as gentlemen whose hearts are black in comparison with his."

In the spring of 1873, Lowe was returning from the horse races held north of town when his own mount threw him. He was carried "insensible" into Ida May's brothel, and a physician called for. He recovered.

Lowe treated Kate well at times and abused her at others. Kate alternated between calling the cops on Lowe and asking that charges against him be dismissed. At some time in 1873, after fleeing him by train that summer, Kate returned to Rowdy Joe.

Lowe's competition was a similar establishment in Delano known as Red's dance hall, owned by E.T. "Red" Beard and located some thirty yards away. Beard's nickname sprung from his curly, shoulder-length red hair and huge mustache, perhaps grown as a counterpoint to his long nose. An Illinois native like Rowdy Joe and Kate, he was the son of the man who founded

Beardstown in that state. Red married the daughter of another good Illinois family and fathered three children before embarking on a wild life on the frontier. There he gained a reputation for being fearless and a good shot.

The summer after Lowe's admiring write-up in the newspaper, Red's place attracted headlines of its own when a company of U.S. soldiers burned it down. The soldiers, members of a cavalry unit en route to Fort Hays, had been cavorting at Red's the previous night. One of them accused a female employee, Emma Stanley, of cheating him out of five dollars. He threatened to shoot her if she didn't return the money. When she refused, he shot her in the thigh a few inches below her hip. Red immediately started blasting away with his own revolver. Before it was over, he'd shot two soldiers who had nothing to do with the fray—one in the neck, nearly severing the base of his tongue, and the other in the calf, splintering his shinbone.

The rest of the company, some thirty soldiers, retaliated the next day. In the early hours of a Thursday morning, they stationed one guard around Sedgwick County sheriff Bill Smith's house, in case he contemplated intervening, and another one at the end of the Arkansas River bridge to prevent any other help from arriving from the east side of the river. The soldiers fired a volley at Red's place and charged inside. They smashed lamps with their guns and ordered Beard's female employees to get out as they set fire to the structure. Someone inside—undoubtedly Red—fired back amid the general pandemonium. By 2:00 a.m., Red's building was in flames and the soldiers were marching back over the bridge in orderly fashion. "How is that for high?" one of the soldiers bragged to a reporter for the *Wichita Eagle* while pointing to the spreading blaze.

Only a kind of citizens' fire brigade kept the fire from spreading to Rowdy Joe's place. Red escaped into the brush with two wounds in his hand and a few bullet holes in his coat. The unfortunate Emma Stanley had been shot again, along with another man found lying about fifty yards from the burning building.

Red rebuilt his dance hall and had opened again by that fall. His new place contained a bar, a dance hall, a kitchen and seven rooms for his female employees and their clients.

There's probably no way two men such as Lowe and Red could have peacefully coexisted next door to each other for long. On the night of October 27, 1873, heavy drinking by both brought matters to a head. Red, who had been drinking in his bar, went to his room and returned with a shotgun and pistol. He threw back one more drink and walked out the door. About an hour later, he was back. Perhaps bored, he used a doorknob for

target practice with his pistol. When a customer tried to do the same, Red put his gun to the man's head and told him he'd blow his brains out if he didn't stop. Then there was an hour of dancing, in which Red took part.

He wandered in and out of his saloon two or three times, stopping at least once in Rowdy Joe's. Red's bartender sent two men to try to keep him out of trouble. When Red's bartender next spotted his boss, he'd returned to his own saloon. He spent about five minutes looking through the east window, which faced Rowdy Joe's dance hall. Then Red took aim with both hands on his pistol and fired out the window. The shot shattered a window at Rowdy Joe's.

Moments later, Lowe and Kate strode in the front door of Beard's saloon. Lowe, holding a shotgun at his hip, asked who had fired the shot. "I done it," Red said and raised his pistol. Red and Lowe fired at nearly the same moment. With gunfire ringing in everybody's ears, two customers dashed out one door and Red ran out another, shooting as he went. The bartender noticed blood dripping off the bar and realized that a customer, Billie Anderson, had been hit. Rowdy Joe had been shot, too, although his neck wound wasn't serious. Red had not been hit, but the gun battle was put on hold temporarily as Lowe and Kate retreated to their place.

The bartender next noticed Red peeking in a window of his own saloon, perhaps to find out if Lowe was still inside. Seeing he wasn't, Red came in looking for his shotgun. He spotted Josephine DeMerritt, a local madam who was his mistress. Red accused her of "putting up a job" on him. DeMerritt denied it. Red threw her on the floor and aimed his pistol at her, cocking the trigger before the bartender and two other men pulled him away.

Red, after a minute or so, went to the dance hall portion of his establishment and shot a woman named Annie Franklin in the stomach, possibly mistaking her for DeMerritt. Then he ran out the front door again. Exactly what transpired next isn't clear. Fifteen minutes later, a few men came into Red's place and reported that he'd been shot on the Arkansas River bridge.

Across the river in Wichita, Rowdy Joe surrendered to City Marshal Mike Meagher outside a billiards hall. Meagher informed Lowe that a shooting in Delano was outside his jurisdiction. He went with Lowe to find Sedgwick County sheriff Smith. Lowe told the lawmen he was so drunk didn't know whether he had shot Red or not. (Stories that Rowdy Joe ambushed Red on the bridge, or that both men rode horses down the street firing at each other, seem to be later embellishments. The *Eagle*, clearly not sympathetic toward Lowe, makes no mention of an ambush. Lowe doesn't seem to have been afraid to confront his enemies. And both men appear to have been too drunk to shoot from horseback that night.)

Red's right arm was shattered at the elbow, and buckshot had lodged in his hip. Initially, it was thought he would only lose the lower part of his arm, but the wounds became infected and his condition worsened. Red told a doctor that if he survived, he'd never go inside a dance hall again, let alone run one. He died two weeks after the gunfight.

Red's postmortem was conducted in a hotel. Several women from his dance hall were there, looking distressed, as was Lowe, who wore a solemn expression. Lowe was ordered to stand trial and released on $2,000 bond.

Rowdy Joe's trial took place in a packed courtroom that December. Prosecuting attorney H.C. Sluss watched helplessly as his case against Lowe fell apart. Sluss was "embarrassed by his own witnesses," who according to the *Eagle* were "composed of men and women in full sympathy with the accused." Sluss could do little but deliver an impassioned closing statement about the sanctity of life and majesty of the law. "The better class of citizens" who were in attendance applauded. The jury retired at 10:00 p.m. and rendered a verdict of not guilty the next morning.

Lowe wasn't in the clear yet. Another warrant was issued for him in the shooting of Anderson, who'd survived being shot in the head but was blinded. Perhaps figuring his luck in Wichita had run out, Lowe slipped away from an officer watching him that night, and a posse led by Sheriff Smith failed to find him. The sheriff offered a $100 reward for Lowe's capture, noting in his description of the fugitive that he had a fresh scar on the right side of his neck from a pistol ball.

Lowe made his way to St. Louis, fooling those who figured he'd head southwest. Detectives in Missouri's biggest city soon became suspicious of Lowe, who characteristically fell in with a disreputable crowd, but they didn't know he was wanted until they received a telegram from a deputy U.S. marshal. The telegram advised that Lowe was traveling under an assumed name and staying at the Laclede Hotel.

Lowe had $8,295 on him when he was arrested January 3 in St. Louis. Sedgwick County sheriff Smith telegrammed St.

Prosecuting attorney H.C. Sluss, who failed to convict Lowe of murder in "Red" Beard's slaying. *Sedgwick County District Attorney.*

Louis police, asking that Lowe be held until he arrived. He'd already made it as far as Leavenworth and could catch the next train to St. Louis, Smith wrote. But Kate had other plans. Six months after trying to flee Rowdy Joe by train, she was back on another train to rescue him—and traveling in style. Smartly attired in a red petticoat, Kate rode in the express car accompanied by a large bulldog and small lap dog. In St. Louis, Kate hired an attorney, who convinced authorities there to turn over the money seized from Lowe to Kate, as his wife. Her attorney then filed a writ of habeas corpus alleging that Lowe was being held in violation of law, since no warrant had been issued against him in St. Louis.

Amid protests from a St. Louis police detective, a judge ordered the release of Lowe, who jumped in a carriage parked outside the jail and disappeared. The handling of the case sparked much commentary, with the *St. Louis Democrat* newspaper noting that "several parties were so rash as to hint that some in authority received a portion of the small change that Mrs. Lowe received."

Sightings of Lowe and Kate continued to make their way back to Wichita, including a false report in 1874 that Lowe had been killed by Indians while hunting for gold in the Black Hills region of what was then Dakota Territory. Six months later, the *Wichita Beacon* reprinted a report from a San Antonio newspaper that Lowe had been found guilty of assaulting Kate and fined $100.

The end for Lowe actually came in 1899 in a bar in Denver after he got into an argument and made known his general distaste for police. A former policeman shot him dead. Lowe had remarried and fathered several children. It's not known when he and Kate split for good.

In present-day Wichita, Lowe and Red have almost become caricatures, perhaps thanks to a restaurant-bar called Rowdy Joe's Steakhouse and Red Beard's Saloon that operated in Old Town from 1994 to 2001. In reality, they were dangerous men. The *Wichita Eagle* bid both a not-so-fond farewell in 1873, saying that Red's fatal shooting was, all in all, a good thing. "Wichita is fast getting rid of that element which has proved such a curse to her prosperity," the *Eagle* declared. That turned out to be wishful thinking.

OF VICE AND MEN

*I*n Wichita, a common civic myth has grown up that goes something like this: The city experienced a few wild, even lawless years as an 1870s cow town, with most of the bad behavior concentrated "over there"—a reference to Delano, at the time an unincorporated area west of the Arkansas River (and now a quaint strip of shops and restaurants well inside city limits). Wichita then settled down to a respectable career as a commercial center and, eventually, Kansas's biggest city.

The reality is a lot more interesting. True, nearly anything went in Delano, but the same could be said of Wichita for much of the city's first half century. City officials tolerated prostitution, gambling and illegal liquor for simple reasons: it brought money into the city's coffers, supported local businesses and helped keep taxes low.

This suspicion that the city's history has been whitewashed has been voiced before. "The Red Light District of 1870s Wichita has been unfairly referred to as being located in Delano or West Wichita by many writers," local historian Ann Wrampe wrote in "Wichita Township Soiled Doves," a paper prepared for the Wichita Local History Series in 1987. "The east side of the Arkansas River, Wichita Township, had numerous professional women in the prostitution business." Wrampe cited old City Court records—which had nothing to do with Delano—showing a dozen women (and one man, a brothel owner) getting cited for prostitution during one month in 1872. Local authorities could have shut down the illegal enterprises by imposing

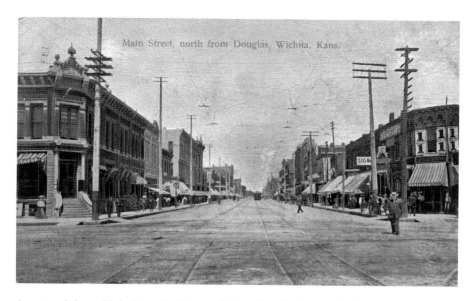

A postcard shows Main Street looking north from Douglas Avenue in the early 1900s. The upper floors of buildings in the city's business district were often used for prostitution and other illicit activities. *Jim Mason.*

the maximum possible sentence. Instead, they levied smaller monthly fines— five to ten dollars for prostitutes, ten to twenty dollars for brothel owners. The same was true for saloons and gambling houses. All these fines "allowed the city the privilege of not levying taxes on the 'respectable citizens' and thousands of dollars were obtained besides to further the interests of the town," Wrampe noted.

Now fast-forward ahead to 1905, when Police Chief Frank Burt (of whom we'll hear much more later) delivered an extraordinary report to the City Council about vice in Wichita. The only thing that had changed from the 1870s was that the city's revenue from it was much higher. During his previous four years as chief, Burt said, police fines on liquor, gambling and prostitution totaled just shy of $150,000. Police department expenses during the same period amounted to about $80,000, leaving the rest to the city as a surplus. Fines collected by police represented a little less than 20 percent of total city revenue.

Burt wasn't quite done. "Now I want to give you," he said, "the plain, unvarnished facts in regard to the underground operations of the department where your chief of police and police officers assume the garb of city scavengers and go out among the violators of the law and levy a species of

blackmail on each and every individual we can find." According to Burt, the city contained forty-two illegal saloons paying monthly fines of $15, $25 or $50 (the chief didn't explain the different rates, but presumably they were related to size). Nine gambling houses paid fines of $50 or $100.

Police regularly fined sixty-five women for practicing prostitution, Burt said. The illegal saloons, brothels and gambling dens were hardly hidden. Most of the woman worked out of the second and third stories of buildings on Main Street and Douglas Avenue, with a few plying their trade on South Lawrence (now Broadway) and Market. (The lack of prostitution activity on Tremont Street—the city's primary red-light district during much of its early history—seems strange at first glance. However, the city that year launched one of many "cleanups" aimed at Tremont.) The saloons and gambling dens occupied the same neighborhoods.

Burt's message seems clear: the city could continue benefiting from illicit activities or it could have an uncompromised police force, but it couldn't do both.

What were the other consequences of Wichita's laissez-faire attitude toward vice? Arguably, it contributed to the harboring of a violent, thieving underworld bent on much more than so-called consensual crime. Not that it can be blamed for all the city's prodigious criminal activity, but it's a theory closer to the truth than that old civic myth.

THE CHRISTMAS CREMATION

*N*ot to dwell on one year in Wichita's history—after all, we've got a lot of wicked ground to cover here—but 1873 turned out to be a banner year for bad behavior. A few months after the Rowdy Joe/Red Beard gunfight, another crime took place that helped cement the city's bloodthirsty reputation.

Before dawn on Christmas morning 1873, a half-naked man leaped out of bed and bravely did his civic duty upon realizing the building two doors down was on fire. First he helped a few women who lived on the first floor out of the building. Then, hearing a groan, he ran around to the back of the house and found a bloodied, woozy man lying on the ground, his feet still on the steps leading to the second floor. He dragged the man away from the blaze, propping him up against a nearby fence. Then he went home and put on some pants.

By then, hundreds of people had gathered in front of the burning building, located at 73 Main Street (just down from Keno Corner then, where the main branch of Intrust Bank sits today), undeterred by a misty fog that had settled over the city. As the second story collapsed, the crowd was horrified to see the "white and ghastly" body of a man fall to the floor, landing with a *thud* on the joists below. The body could not be retrieved from the smoldering fire until the next morning, by which time positive identification was impossible.

Needless to say, the talk around Christmas tables in Wichita that day was about more than punch and presents.

The man found lying outside the burning building was Arthur Winner. He told a dramatic story about how he got there. Winner said he'd gone to sleep that night next to his business partner, Joseph McNutt (same-sex sharing of beds was common in those days). He'd been roused from his slumber, he said, by someone hitting him. Jumping from bed, he'd staggered into the next room and shouted, "Look out, Joe!"—only to be clubbed in the head and knocked out. The next thing he knew, he was being pulled from the steps of the burning building.

Winner, shown the corpse retrieved from the fire's embers, couldn't claim to recognize the charred, faceless remains. But he said a piece of vest found on or near the body belonged to McNutt. He also identified an envelope, now empty, which had been found nearby and in which McNutt had supposedly been carrying a large sum of cash. The implication was that McNutt had been robbed before perishing in the blaze.

Almost from the first, some people thought there was something suspicious about the fire. They were right. The fatal fire became known as the "Christmas cremation" and for decades ranked as one of the most infamous crimes in Kansas history.

The perpetrators, Winner and McNutt, started out as partners in a sign painting business in Kansas City. Winner came from a wealthy Kansas City family; he was nineteen and single. McNutt possessed artistic talent. He was originally from Nova Scotia, a year older than Winner and married. Relocating to Wichita, the two stylishly dressed young men stayed in the Southern Hotel for a few weeks and then rented the second floor of the house on Main Street, which served as both domicile and business for several tenants. Below them lived two women who ran a millinery shop. Behind the women lived a couple of card sharks.

McNutt and Winner painted enough signs to impress others in Wichita as "enterprising, clever and industrious," according to a contemporary account. Privately, they laughed to each other about the inferior work of some local competitors. But the real point of setting up shop seems to be that sign painting required material—oil-based paint—that was eminently flammable.

In December 1874, they enticed W.W. "Tex" Sevier, a fellow sign painter McNutt knew from Kansas City, to join them in Wichita. Sevier was something of a drifter and a drunk, "good-natured and not inclined to be quarrelsome," with no known family. Winner wired him money for a train ticket to Wichita. Sevier telegrammed that he was on the way. The last confirmed sighting of Sevier occurred as he was changing trains in Topeka

on December 24. Meanwhile, in Wichita, McNutt had bought a bottle of whiskey and a vial of laudanum, a powerful sedative.

A coroner's jury was summoned to rule whether the death of the man supposed to be McNutt was natural, accidental or deliberate. The work of such juries was usually quick, but in this case, police and an insurance company asked for several continuances as several pieces of evidence emerged casting doubt on Winner's story.

One was the discovery that McNutt had three months earlier taken out a $5,000 life insurance policy on himself, payable to his wife, whom he'd married the day before moving to Wichita. Another was the finding of telegrams sent between Winner and Sevier, discussing the latter's move to Wichita. Police were unable to locate Sevier or anyone who'd seen him since Topeka. Then there was a letter, addressed to McNutt but delivered to police, that arrived in Wichita within hours of the fire. The writer was his wife. The letter contained several urgent pleas that McNutt not take part in some unspecified act, as well as this advice: "Do cut loose from Winner.... He is a pinchblack liar. If you carry that on we will be ruined. Before I will have the name of stealing and murdering for wealth I'll beg on my hands and knees."

Winner was indicted on murder charges that January along with the missing McNutt. Despite the mounting circumstantial evidence, Winner remained confident of acquittal. After all, if it couldn't be proven that the dead man was Sevier and not McNutt, how could he be convicted?

Winner remained optimistic right up until February, when McNutt was found, very much alive, in Ray County, Missouri, about 240 miles away. Former sheriff Bill Smith, tipped off by a friend to whom McNutt had written, surprised him on a farm miles from the nearest town or railroad. McNutt had shaved off his whiskers and dyed his hair but made no attempt to deny his identity when Smith snuck up on him with a shotgun. "Well, you have got me, ha'nt you?" he said.

McNutt initially maintained his innocence. He claimed that he'd run off and hid because he'd discovered a plot to kill him that had been concocted by his wife, Winner and Sevier. Once he'd learned of the fire and murder, he'd been too scared to give himself up. In custody, McNutt reportedly told police a different story, admitting that he'd gone along with Winner's plan

to kill Sevier, fake his own death and collect on the insurance policy. Sevier was drugged and bound, doused with kerosene and set afire, McNutt said. Portraying Winner as the mastermind of the plan, McNutt also accused his codefendant of robbing the Kansas City Fair the previous year.

There was also a purported second confession, written up by a correspondent for a Kansas City newspaper and reprinted around the state, that contained enough sensational details to guarantee the murder would long be remembered. In this account, Winner and McNutt plied Sevier with a mixture of brandy and ether until he lost consciousness. They then placed his head in a pot of benzene—an industrial solvent used in paints—and set it on fire, until "his head began to simmer and crackle like burning meat." After laying Sevier on the bed, already saturated with oil, McNutt helped Winner drain some blood from a vein, which the latter then splashed on himself.

As to why the pair picked Wichita for their scheme, McNutt said his partner got the idea by reading newspaper stories about the place. Winner had found "a place where we could execute our deeds in broad daylight without being bothered by the law; a place where men were killed every day in the week, and that place was Wichita."

The trials of Winner and McNutt were held one week apart in the rambling old Eagle Hall on East Douglas, which contained not only a courtroom but also a newspaper, county offices, lodges and an opera house. Winner's defense was that he couldn't be convicted of killing Sevier—as the indictment charged— if the dead man couldn't be positively identified. McNutt, on the other hand, testified that he'd run from the scene of the fatal fire as soon as Winner and Sevier arrived that night, convinced that they meant to kill him. He said he no longer believed his wife was part of the plot.

Jurors convicted both of first-degree murder, and Judge W.P. Campbell sentenced both to hang; that translated into life sentences because Kansas governors of that period declined to issue execution orders. They were among the first killers from Wichita to be sent to Lansing prison in Leavenworth County.

Despite the premeditated, avaricious nature of the crime, the two young murderers were not considered beyond redemption. Winner's father, a Kansas City businessman named W.P. Winner, spent almost twenty years trying to get his son and McNutt released, traveling frequently to Wichita to seek support. He reportedly budgeted $20,000 for the effort. In the Lansing

penitentiary, Arthur Winner was assigned to work in the shoe factory, which made footwear sold to the general public. He quickly rose to foreman of the operation and also taught other inmates in the prison school. McNutt developed into a painter of more than just signs, adorning the prison chapel with his work, and led the prison chapel choir. Both men were said to fear that they would eventually lose their minds and be assigned to Lansing's insanity ward.

In 1893, the elder Winner's long campaign finally paid off, thanks in part to Wichita lawyer (and state senator) O.H. Bentley. Hundreds of people signed a petition asking Governor Lyman Humphrey to pardon Winner and McNutt, including the trial judge and foreman of the jury in the case. Humphrey did so on his last day in office. Winner whooped and hollered when he got the news. McNutt wept.

A newspaperman met the two men as they walked out of the penitentiary. They stopped in an adjacent field, admiring each flower and animal they spotted, the sunlight and the open breeze. That night, Arthur Winner's family treated both men to feast at a downtown Kansas City hotel.

There was concern that McNutt lacked the kind of support system outside bars that Winner enjoyed. McNutt's wife had divorced him and remarried after giving birth to a child. But he did fine, starting a sign painting business in Leavenworth, in the same county where he'd served his sentence.

Arthur Winner went to work as a traveling salesman for the shoe company with the prison contract. He visited Wichita a few months after his release from prison, expressing amazement at the city's growth since he'd last seen it. Most of the landmarks he remembered were gone, although he recognized the building where he'd been sitting when he learned that McNutt had been captured. To another newspaperman, the now-bald Winner seemed to have aged far more than twenty-one years.

Winner said he felt good. He implied that dissolute habits might have played a role in the heinous crime he'd committed; he said he hadn't touched whiskey since the Sedgwick County sheriff had given him and McNutt each a shot shortly before their sentencings. He never directly apologized or acknowledged guilt, but that he was sorry there could be no doubt. "So much was lost," he said.

A HARLOT SCREAMING
FOR RUM

*P*oor Willard Boone. In 1893, he was the newly elected Sedgwick County attorney, making him the top law enforcement official for Wichita and surrounding towns.* Something of a legal prodigy, the Indiana transplant started practicing law seven years earlier, at the age of twenty. He and his friends made up the smartest young set in Wichita, their dancing and card parties the perfect setting for Boone to woo one of the local belles as his future bride. Meantime, Boone supported his mother and three sisters in a home on North Market Street on his county salary and earnings from outside legal work.

Two years later, Boone found himself out of a job and fighting to keep his law license. He ran face first into the issue that convulsed and corrupted Kansas for sixty-seven years: prohibition. Boone stood accused of taking money from saloons operating in violation of Kansas's 1881 ban on intoxicating beverages. In turn, he accused Wichita's police chief, Rufus Cone, of being a silent partner in the city's largest wholesale liquor operation and Governor Lorenzo D. Lewelling, another Wichitan, of sanctioning the illegal liquor trade.

It all made for sensational headlines, complete with tales of attempted blackmail, threats, a fistfight and the county attorney getting tossed out of a saloon. And it was one of many times that the city's long defiance of Kansas law was laid open. That officials charged with enforcing prohibition might seek to profit from it instead should not have been surprising. As the

* The office's title was changed to district attorney in 1973.

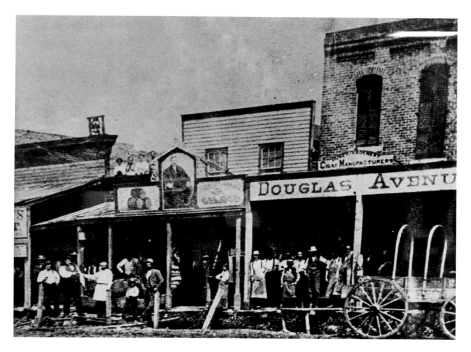

Fritz Schnitzler's saloon, one of many in Wichita that Kansas's prohibition law failed to shut down. *Wichita Public Library.*

Leavenworth Times said a few years after the state's prohibition law took effect, Wichita "has become a harlot, screaming for rum."

Not that the city ever seems to have been denied a stiff drink. Alcohol had played a major role in Wichita's culture since before the city officially existed. A stick-and-sod tavern called the Buckhorn served as the city's first social center. It opened near what's now the corner of Eighth and Waco in the late 1860s with a dirt dance floor and music box. Other watering holes that followed included the Clipper, Star of the West, Custom House (also known as the Syndicate), Phoenix, Long Branch and Little Gem. Most sat on Douglas, the city's main thoroughfare.

While some were rowdy, others were respectable gathering places. Among the latter was Fritz Schnitzler's Apollo Saloon, which sported a large painting of its proprietor over the entrance at Douglas and Main. Schnitzler was as famous for his girth and the food he served as for his drink, his establishment being capable of feeding 150 men at a time. Emil Warner's Bavarian-style beer garden featured a bowling alley, a concert room, a dance floor and beer brewed on the spot. Another beer garden,

Feichheimer's Grove, on the banks of the Arkansas River, provided a gathering spot for the area's German families on Sunday afternoons despite an early city law attempting to outlaw drinking on the Sabbath.

One of the biggest wholesale liquor distributors was James Dagner, father of the woman who would become Willard Boone's wife. Several brewers made beer in addition to Warner, including Abe Weigand, who produced more than 2,400 barrels one year. Weigand offered free lunches at his establishment for those sampling his product.

James Hope, a liquor dealer, and George Harris, a saloon owner, served terms as mayor in the 1870s. Saloons produced major revenue for the county through an annual $500 licensing fee, helping keep taxes low. Fines for drunkenness and disorderly conduct added to city coffers.

Then in 1880, Kansans, led by a charismatic Republican governor named John St. John, voted in favor of prohibition, which outlawed the selling and manufacturing of intoxicating beverages in the state (with some exceptions). Of some 176,000 ballots cast, "drys" beat the "wets" by 4.5 percent. Sedgwick County voters backed the constitutional amendment by about the same margin, but the county soon rebelled against it, along with other population centers such as Leavenworth, Atchison and Wyandotte Counties (all of which voted against it in the first place).

Interestingly, the staunchest support for prohibition came from counties around Wichita—Cowley, Lyon, McPherson, Butler and Sumner Counties. Their newspapers became the source of many of those "Wicked Wichita" references.

Prohibition went into effect in May 1881 amid many questions about how it would operate. The answer, at least in Wichita, was erratically, when it operated at all. Enforcement was left to local authorities, and Wichita officials balked at losing the revenue collected from saloons. Instead, they instituted a system under which saloons were regularly fined but allowed to stay open. From May to December 1883, for instance, one of Willard Boone's predecessors, Sedgwick County attorney Dave Dale, undertook 110 liquor prosecutions, pocketing $1,814 in fees. Dale was neither for nor against prohibition, the *Eagle* reported. "He was strictly for Dale."

Some liquor dealers exploited a loophole in the law that allowed drugstores to sell alcohol with a physician's prescription. Schnitzler's saloon, for instance, promptly became a drugstore. The requirement of a physician's prescription was later dropped. At times, depending on political pressure or public opinion, saloons and drugstores were shut down, only to reopen again a short time later.

This sporadic enforcement of prohibition led to all kinds of absurdities. In 1885, Governor George Washington Glick spent the afternoon at his old friend Schnitzler's place. Often, the same newspapers that ran editorials about the need for consistency in prohibition enforcement carried advertisements for Anheuser-Busch beer, imported from neighboring Missouri. In 1887, a Wichita beer dealer was sued by a Missouri brewer for $3,000, the amount he'd spent for a three-month supply of the supposedly illegal commodity. That same year, the legislature passed the Metropolitan Police law in an attempt to force Wichita and some other cities to enforce prohibition; under it, the governor could appoint local three-member commissions that took overall responsibility for the police departments in targeted cities. In Wichita's case, the commission was "impotent," Kansas historian Robert Smith Bader concluded in his book, *Prohibition in Kansas*. "Wichita waged an especially strenuous fight, the outcome of which allegedly determined whether it was 'greater than the state of Kansas'…. Charges of corruption among officials became commonplace."

In 1888, a grand jury indicted another one of Boone's predecessors and seven more county officials for taking bribes from "jointists," as saloon operators and bootleggers were called. The grand jury reported that the city's entire police force was corrupt. Two years later, Wichita's police commission closed fifty-two joints, only to let them reopen soon after. The city again settled in to a system of fifty-dollar monthly fines per joint.

Whether this was all a good or bad thing depended on whom you asked. "Wicked Wichita is about the only flourishing town in that state and they pay no attention to Prohibition down there," a Nebraska newspaper reported.

From the late 1880s on, some Kansans clamored for a do-over vote on prohibition, or "resubmission," as it was known. In Wichita and Sedgwick County, a resubmission club with 1,800 members—many said to be Republican businessmen—led the charge. Prohibition, they argued, fostered hypocrisy, slowed immigration to Kansas and hurt the economy. They also sensed that it had become unpopular with voters, as confirmed in the 1890 election when candidates from the Populist Party (which took no formal stand on prohibition) won a majority of the state's U.S. Congressional districts and seats in the Kansas House of Representatives.

It was in this atmosphere that Willard Boone ascended the local political ladder to Sedgwick County attorney. A native of Bedford, Indiana, Boone moved to Wichita in 1886 to attend Southwestern Business College, a school on Main Street that attracted students from around the Midwest. In addition to qualifying as a lawyer, Boone quickly joined the city's social set, helping charter the Coronado Club for music, games and dancing. By 1890, Boone was speaking on behalf of resubmission and the Democratic Party. His mother and sisters joined him in Wichita. His blond hair, blue eyes and ruddy cheeks were the topic of a social column in one newspaper.

Boone ran for the Democratic Party county chairman post in 1891 but was outmaneuvered by Sam Amidon, who would become one of the most important attorneys and political figures in the city. The next year, however, Boone won the party's nomination for county attorney over Amidon. (He was also supported by the Populist Party, being what was known as a "fusion" or Demo-Pop candidate.)

Boone was the star of a political rally that September in Hyde Park, near Hydraulic and Douglas. A supporter hoisted him onto his shoulders and carried him to the stage. "The young men look to him as their special champion" and "frequently interrupted his speech with uproarious applause," the *Beacon* reported. The rival *Eagle* sniffed that the crowd "looked like the junior class in a Sunday school."

Although favored in the approaching election, Boone took nothing for granted, courting votes in all the city's political wards, Garden Plain and other surrounding towns. If he needed any sympathy to put him over the top, it came on the eve of the election, though not in a form he could have wanted. To reward his sister for graduating from Lewis Academy, a Presbyterian school in Wichita, Boone had sent her on a trip to visit relatives in Indiana. Florence Boone died there suddenly of typhoid fever. Boone immediately left for the Hoosier State, leaving last-minute campaigning to his supporters as news of the tragic death spread. He won the election.

As county attorney, Boone advised the county commission and handled an array of criminal cases. He convicted a forger represented by attorney O.H. Bentley, scorning Bentley for trying to capitalize on the fact that the defendant fought for the North in the Civil War. He prosecuted a woman for adultery. He showed some independence, aggressively prosecuting a police department employee from his same political party who was accused in a wrongful killing. Even the *Eagle* praised him over that case.

That summer, he traveled north to settle a large estate case in Michigan, attend the World's Fair in Chicago and visit relatives in Indiana. Back in

Wichita, Boone went after an organization called the Sedgwick Law and Order League over financial irregularities. "You are a scoundrel and a rogue!" Boone said to the group's leader, a minister, in a courtroom. He prosecuted two school board members for allegedly demanding bribes from teachers to secure their jobs. "At the rate at which Willard Boone is sending criminals to the penitentiary Sedgwick County will soon be a very safe place to live," the *Beacon* wrote in February 1894.

In June, one month after suffering an attack of malaria, Boone married Elizabeth Dagner, daughter of a liquor dealer and "one of the handsomest brides that ever stood before an altar in Wichita," at St. John's Episcopal Church. The *Eagle* called it a "Great Social Event." Boone built his new bride a ten-room house at 1038 North Market, current site of the Chateau Villa apartments. He was seen as a shoe-in for re-nomination by the Democrats, although the fact that he had angered Populists while in office ruled him out as a fusion candidate.

Nothing in Boone's political or personal background suggested he would aggressively enforce prohibition. Nonetheless, as county attorney, he felt sworn to uphold the law. Early in his term, he appealed a decision by Judge C.V. Reed to throw out several liquor cases on technical grounds. Boone's first clue that he wasn't actually expected to do his job came just a few months into his term, through his contact with the wishy-washy Governor Lewelling of Wichita. Lewelling was one of many Kansas politicians over the years who found themselves obliged to give lip service to prohibition.

In a conversation in Topeka, Lewelling told Boone that Boone's "first step toward closing the joints in Wichita was taken sooner than he [Lewelling] intended," yet it was "as good a time as any to move." Lewelling sent Boone back to Wichita with instructions to tell the Metropolitan Police commissioners "to do everything in their power to assist you in every way possible to suppress the liquor traffic in Wichita." However, when Boone got back to Wichita, he discovered that Police Chief Rufus Cone and a member of the police commission had gone to Topeka to confer with Lewelling on their own. When they returned, the police commissioner handed Boone a letter from the governor. It stated that "upon further reflection," Lewelling had decided to let the police commission "do whatever in their judgment seems best in regard to liquor traffic, as they are on the ground and can understand all the bearings in the case." And the commission's opinion was that it "would

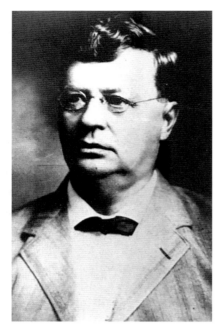 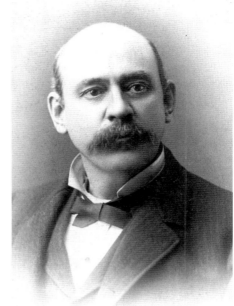

Left: Police Chief Rufus Cone, foe of County Attorney Willard Boone. *Wichita Police Department.*

Right: Governor Lorenzo Lewelling of Wichita waffled over enforcing prohibition. *Wichita–Sedgwick County Historical Museum.*

be in the best interests of the administration to let the joints run," but not to let any new ones open. Boone was willing to accept the decision of Lewelling, but only so long as it did not violate his oath of office to prosecute crimes when sufficient evidence was brought to his attention.

After starting the first of several such successful prosecutions that he felt he could not avoid, Boone said he was warned by Chief Cone that "if you commence any more cases against the whiskey men they will get up a mob and mob you." Boone understood Cone to mean that the police would not protect him. Cone also told Boone that any citizens who swore out complaints against liquor sellers would likely be attacked by men the whiskey faction could hire for the sum of five dollars and travel expenses from the Indian Territory.

In September 1894, after filing more liquor cases, Boone received another warning—this one from H.L. Taylor, the state oil inspector and another Wichitan. "Willard, I come to you as a friend," Boone said he was

told. "Some of these fellows are going to try to get your scalp unless you drop these liquor cases you have commenced and refuse to commence any more."

Several weeks after this conversation, Boone went public with his allegations against Chief Cone. Or rather, he detailed them in a letter to Kansas attorney general John T. Little that somehow found its way into a Topeka newspaper even before it reached Little's hands. In addition to the accusations of dealing in liquor, Boone charged that Chief Cone and other police officers had been looting the city treasury through their handling of fines for liquor dealers. "According to statistics compiled by reliable parties," Boone said, there were thirty-three liquor joints in the city "running wide open," numerous bawdy houses where "unfortunate women" plied their trade, two gambling houses and several other businesses whose mode of operation subjected them to regular fines. In summary, the city should have been collecting about $3,400 per month in fines, but the records reflected less than half that amount. Police recorded the fine payers under fictitious names, Boone said, making the whole matter hard to trace. Because of Cone's relationship with a liquor operation run by the Mahan brothers, Boone said, police were actually trying to control the liquor traffic in Wichita "to the injury of all other wholesale liquor men in this city." (Boone seems to have forgotten here that the whole liquor business was illegal under state law.)

Little, after receiving Boone's letter, appointed the county attorney's old Democratic Party rival, Sam Amidon, as a special assistant attorney general for Sedgwick County, exercising one of the powers the legislature had granted the attorney general to enforce prohibition. However, Little pointedly said he did so not because of Boone's letter but because Sedgwick County residents had sent him a petition stating that Boone himself was ineffective in enforcing prohibition.

Boone wasn't completely innocent. He had neglected to mention one embarrassing fact in his missive to the attorney general: on a Sunday afternoon that same month, he had been found by police detectives Harry Sutton and Bedford Woods enjoying himself in the illegal saloon of the Manhattan Hotel in downtown Wichita. According to the officers, an intoxicated Boone told them his authority overrode that of police, and he had determined that the establishment should stay open despite their intention to shut it down that afternoon. Then he helped himself to another beer from the icebox.

Boone taunted the officers with an offer of $100 to arrest him until they finally threw him out into the street.

Rumors of the encounter apparently percolated for several weeks before the *Beacon* broke the story on October 13. The *Beacon* decried the "disgraceful" row between Boone and police as damaging to the city's reputation and speculated that Boone might be a "boodling drunkard" ("boodle" referred to graft by public officials). The *Eagle*, meanwhile, seems not to have judged the event newsworthy. Instead, it dug up evidence that Sam Amidon—the man appointed to enforce prohibition in Wichita—was the attorney of record for the Mahan brothers' liquor operation.

If you're keeping track, you'll see that the city's two newspapers had now swapped positions on Boone—with the Democratic *Beacon* attacking him and the Republican *Eagle* coming to his defense, or at least considering him much less of a menace to the public than Chief Cone, whom the paper referred to as "Boss Cone."

A reporter for the *Eagle* caught up with Chief Cone at police headquarters. After more than a century, it's still possible to hear the contempt in Cone's voice as he said he'd been "enjoying the fun hugely and hope it will be kept up….I have no words of abuse for my enemies, or words of commendation for my friends, at this time. The hardest I have ever said or have now to say

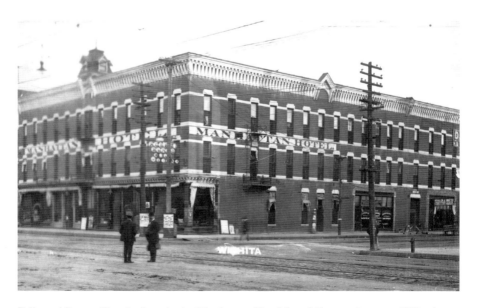

Police raiding an illegal saloon in the Manhattan Hotel found County Attorney Willard Boone inside. *Jim Mason.*

is that I am sorry for that little whiffet Willard H. Boone. It is no time to talk, but I hope he will keep up his one-sided war. It don't hurt me and appears to do him good."

Boone denied being drunk at the Manhattan. But he soon had another, more serious professional crisis to deal with. It started when an attorney named W.J. Skelton walked into his office one afternoon in December. "I want $250 out of you," Skelton said. Skelton explained that he was that much in debt, and he knew Boone had made plenty of money by taking money from illegal liquor operations. He was prepared to expose Boone if he refused to give him the money.

Boone punched Skelton in the face. The two men grappled and fell the floor in a heap before being separated; exactly what happened depended on who was asked. Skelton claimed that he "could whip him if I cared to fight that way, but I don't." A reporter for the *Eagle* who'd witnessed the end of the fight disagreed, saying that Boone wound up on top, punching Skelton's face "with the regularity of a pump." Skelton made good on his threat days later, filing disbarment papers against Boone. Never one to back down, Boone filed blackmail charges against Skelton the next day.

Skelton's preliminary hearing on blackmail charges took place first. Boone, Skelton testified, had hired him the previous summer, saying he "intended to prosecute the saloon men to the finish." Skelton said he signed on—"for I believe in law and order"—but refused to do any lowly surveillance work, leaving that to others while he prepared the legal papers. Skelton said he came to believe that Boone was shielding one saloon man, a friend the county attorney said he "could not prosecute…just then, but would later on." Supposedly upset by this state of affairs, Skelton quit and demanded his legal fees to date, $500, which Boone had refused to discuss with him. After hearing the evidence, a judge bound Skelton over for trial. Boone, who would have been the chief witness against Skelton, let the blackmail case drop after leaving office.

Boone had long since given up hope of standing for reelection. Now he was battling to keep his law license. His disbarment hearing over Skelton's allegations took place in January 1895, after he had left office. A saloon owner named Jack Davidson swore that Boone dismissed a charge he'd filed against him for $50—half payable in cash, half in forgiving Boone's bill for wine and cigars. Boone had wanted $100 more to settle two additional cases. John Mahan and several other men in the liquor business testified similarly. A young German immigrant said Boone had dismissed his case when he forgave a $75 bill at his butcher shop. Nearly every attorney in town watched the case from the courtroom seats.

Boone, in his testimony, did not deny taking money but said that he believed he was entitled to twenty-five dollars in fees for every liquor case he handled, based on advice he'd received. He was unable to cite any statute entitling him to such fees. Speaking of prohibition generally, Boone said he'd learned that the police, business community and most residents were against enforcing it. "I got no assistance from the police force," he told the packed courtroom. "I knew that if I undertook to do anything personally I was liable to get laid out." Boone claimed that police detective Harry Sutton—who testified against him regarding the incident in the Manhattan saloon—once called him into a drugstore that sold liquor and told him "if I let up he'd get me $200."

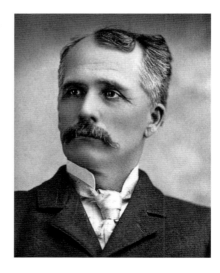

W.E. Stanley, Wichita attorney and future governor, reluctantly prosecuted Willard Boone's disbarment. *Wichita–Sedgwick County Historical Museum.*

W.E. Stanley, the attorney (and future governor) appointed to handle Boone's disbarment, sounded apologetic as he described the pain of putting his friend through such an ordeal. Boone might well be a "young man, lacking somewhat in courage," Stanley said, but much of the blame lay with the city and its legal establishment. "The sentiment of this city has become absolutely debauched with regard to prosecutions of violators of the liquor law," Stanley declared, adding that the case would never have arisen "if the officers that had preceded Mr. Boone had lived up to their duties as they ought to have done."

Judge Reed suspended Boone from practicing law in Kansas for a year, saying that he didn't want to deprive the young lawyer of his ability to make a living permanently.

Willard Boone's fall had no significant effect on the enforcement of prohibition—or rather the lack thereof—in Wichita. Neither did dozens of other dust-ups over booze through the decades, including the much-ballyhooed visit of Carry Nation to the saloon at the Carey Hotel in 1900. Nation wasn't even the first woman to attack a saloon in Wichita. A woman named Mary Elmer holds that honor, taking an axe to a saloon and gambling den in 1888 after warning its proprietor not to serve her husband alcohol.

The simple truth was that a large number of Wichitans felt that having a drink was their right. And those who were so inclined figured out ways to get one until prohibition was finally erased from Kansas law in 1948.

As for Boone, he did all right. Two months after being disbarred in Kansas, he was reported to be handling the estate of a murdered millionaire in Chicago. By the next year, he was practicing with a firm in that city. His wife visited Wichita, but there is no mention of Boone ever setting foot in the city again.

WRONG SIDE OF THE TRACKS

*B*eing poor wasn't illegal in early Wichita, but it could be hazardous to your health. Despite the city's growth, the Peerless Princess of the Plains was home to numerous destitute families.* In 1885, Sedgwick County voters approved the creation of a "poor farm" located on 160 acres southeast of the city. It provided housing and work for about forty to fifty people at a time. A spectacular real estate bubble blew up two years later, adding to the communal pain. Like other Kansas counties, Sedgwick County employed a "commissioner of the poor" to evaluate requests for help and dispense public aid. The number of families served each month ranged from a few dozen to several hundred.

In the spring of 1893, just as the United States was heading into one of the greatest economic panics in its history, the Santa Fe Railway reported a rash of thefts of coal from its yards in Wichita. Coal did more than power trains; it was what people burned to heat their homes. Responding to the Santa Fe's complaint, the city deployed two brand-new, trigger-happy employees to act as private guards for the railroad. One of the men, John Scully, had been hired as a policeman in March with specific orders to arrest chicken thieves and other petty criminals. That month, Scully caught a man stealing coal. When the man ran, Scully shot him in the heel. Scully said he had been aiming at the ground.

* The "Peerless Princess" nickname was apparently coined by *Eagle* publisher Marsh Murdock in a typically boosterish November 27, 1886 piece that began, "How she spreads! Wichita!"

The next night, a man named Wesley Spidle ventured out to steal coal from the Santa Fe (probably not having heard of the earlier shooting). Spidle was about forty years old, unshaven and clad in the roughest sort of clothes. He lived with his wife and four children in a cottage at 330 North Mead, two blocks from the tracks (and current site of the *Eagle*). The family had moved to Wichita from Indiana a few months earlier. Spidle spent the winter looking for work, finally finding a job as a gardener north of town about a week before attempting to swipe the coal. His two older sons, eighteen and fourteen, worked alongside him as gardeners, but none had yet received a paycheck. There were two additional mouths to feed—a daughter, eleven, and son, five—at home.

Spidle's accomplice that night was a younger man named William Mitchell. The two were in the act, coal sacks slung over their shoulders, when Officer Scully snuck up on them. Scully put Spidle under arrest and then turned him over to his partner for the night, C.L. Irish. Irish wasn't actually a policeman. A middle-aged Civil War veteran like many Wichita men of the time, he'd been given a job at the police department as turnkey and general handyman thanks to his enthusiastic support of the Democratic-Populist fusion party in the recent election. Irish, who had nine children of his own, volunteered to go along with Scully to the Santa Fe yards; perhaps he thought it might lead to a better-paying position on the police force.

Officer Scully proceeded up the track about seventy-five yards to nab the second suspect, Mitchell. Meanwhile, Wesley Spidle jerked away from Irish and made a run for it. Irish fired a warning shot into the air from his .38-caliber revolver. His next shot hit Spidle in the back, tearing through his body.

Irish claimed that the shooting was an accident. After firing the warning shot, he said, he'd taken a few steps after Spidle, tripped and sprawled onto a railroad tie. As he did, he threw out his gun hand to break his fall. The revolver discharged. That Irish honestly regretted the result seems clear. He helped Spidle into a nearby house, from which a carriage eventually took him to the city hospital. Irish, crying like a child, handed his revolver to Police Chief Rufus Cone and said he never wanted to see it again.

Witnesses later testified to hearing two conversations between Irish and the wounded man. In one, recounted by a mail carrier, Spidle told Irish that he thought it was wrong for him to have shot him. "If you had halted when I asked you, I wouldn't have shot you," Irish replied—a remark that could be interpreted in more than one way. The other conversation—overheard by a physician—went like this:

Spidle: "I know I was doing wrong in taking the coal, but I ought not to be shot for it."

Irish: "I did not mean to shoot you. It was an accident."

Spidle: "Goddamn you, you did mean to shoot me, as I was only about ten feet away from you."

Spidle grew weaker and died at about 7:45 a.m. the next day. The same day, Chief Cone pledged to abolish the use of "double-action" revolvers—which automatically get the next round ready each time the trigger is pulled—if he "had to give [officers] pitchforks in their stead."

The shooting generated considerable sympathy for the victim and his family. A reporter for the *Eagle* who visited the Spidle home found no food in the house except for that which had been brought by Chief Cone's wife. Spidle's widow could not leave her bed to take care of her children; she had been sick for years. The blue-eyed youngest boy sprang to the door when the reporter knocked, only to sink back when his father did not appear. He seemed to know "that there was some terrible calamity overhanging the family, but that he only half understood it." The *Eagle* opined that most men would have stolen coal to warm their family under such circumstances. As for Irish, the officer "seems to be either careless, awkward or unfortunate when it comes to firearms." About ten days earlier, the newspaper reported, Irish had nearly shot a woman who was trying to smuggle whiskey into the city jail.

Medical evidence in the case was inconclusive. At the coroner's inquest, Dr. McClees testified that the bullet, after hitting Spidle in the back, traveled at an upward angle and finally exited his body about three inches higher than where it entered. That left open at least three possible explanations. One was the story given by Officer Irish. Another was that Irish was standing erect when he fired, but that Spidle had been leaning forward as he ran, a not uncommon posture. A third was that Irish fired from the ground after taking careful aim. This last version seemed least likely because several witnesses reported hearing the gunshots fired in rapid succession.

Officer Scully and William Mitchell, Spidle's accomplice, both claimed to have seen the entire episode from a distance of 250 feet, the scene lit by a streetlamp. They corroborated Irish's account. But both were "interested parties" in the case whose testimony might be doubted.

Judge J.C. Redfield found that there was sufficient evidence for the policeman to stand trial, saying he did not see how Irish's revolver could have fired upward while the policeman was trying to break his fall. Mitchell's testimony, the judge added, was "practically worthless."

The *Eagle* went further, alleging that Mitchell falsified his testimony in exchange for the police department dropping charges. Citing no sources by name, the newspaper reported that a policeman who interviewed Mitchell had this reaction: "Jesus Christ, it will never do to keep that man in jail. He tells a terrible story, and we must keep on the good side of him."

Ironically, the Spidle family enjoyed a windfall of material goods after the shooting. Food, underwear, socks, dress cloth and more were donated by local merchants. Chief Cone's wife spearheaded the drive. Spidle's widow recovered sufficiently to attend Irish's trial that fall, although she still appeared "very delicate."

Little new evidence was introduced at the trial apart from Irish's admission that he had once served a prison term in Indiana for stealing bees. Jurors deliberated a few hours before convicting him of manslaughter. A judge gave him the minimum sentence of six months in jail, commuted to time served by Governor Lewelling in February 1894. Irish returned to political activity with the Democratic-Populist party after his release, attending conventions as a delegate and even running as its city council candidate in the Second Ward in 1905. He finished last, receiving 30 votes out of 1,312 cast.

THE NOTORIOUS DIXIE LEE

On April 25, 1889, the regular occurrence of a somewhat irregular proceeding took place. In the city's Police Court that day, a number of "soiled doves"—the newspapers' usual term for prostitutes—showed up to pay their monthly fines of ten dollars. One defendant sent her housekeeper and twenty-five dollars instead: Dixie Lee, madam of the classiest brothel in Wichita.

On the bench, Judge A.R. Museller was not impressed. He told the housekeeper that Dixie must come herself in the future. If Dixie felt herself too nice for such an errand, he added, she "had better go out of the business." Despite the judge's opinion, there was something different about Dixie Lee, whose real name was Inez Oppenheimer. Oppenheimer successfully ran an illicit enterprise located in the center of Wichita (just north of where the Garvey Center stands today) for years. Thanks to newspapers, Dixie's name became a byword for vice across Kansas, injected into political battles whenever convenient.

Despite the stigma attached to her business, she stood up to local authorities when she felt her rights were being violated—and sometimes won. She barely escaped being murdered by her crazed ex-husband. By the time of her death, she was known from Kansas City to San Francisco and had amassed a fortune estimated at $2 million in today's dollars. In her day, Dixie/Inez had many epitaphs hurled at her. The *Eagle*, for instance, once labeled her "the most wicked woman in the history of Wichita." Having experienced a wide strata of early Wichita society, Dixie surely laughed at that notion.

Her early life gave little indication of what was to follow. According to local historian Anne Hathaway Boll and William Griffing, a distant cousin of Dixie's, she was likely born on a farm in the southeast corner of Nebraska. The young Inez Griffing could count respectable and somewhat prominent ancestors on both sides of her family. During her childhood, Dixie's mother ran a restaurant and boardinghouse in Falls City, Nebraska, while her father attempted to farm until his death at the age of forty-five.

Her mother, pregnant with her fifth child at the time, soon married again, to a violent ex-convict who moved the family to California. Although Dixie's whereabouts for the next dozen years aren't known, Boll suggests that she refused to accompany her family to California and instead moved to Kansas City to live with a relative, who coincidentally resided near a high-class brothel. Boll argues—plausibly enough—that Dixie learned her trade in Kansas City before heading west to Wichita.

Dixie practiced her trade in Wichita at least as early as the summer of 1886, when she was listed among "a number of unfortunate creatures of the female persuasion" who police found "loitering around houses of ill-shape." A catchy nom de plume was apparently a job requirement, as her

Dixie Lee's brothel flourished for years on Wichita Street just north of Douglas. Part of it can be seen beyond the old Missouri Pacific Railroad depot. *Wichita Public Library.*

fellow detainees included "Gussie Out," "Maud Bribe" and "Bessie Bright." Each made a "contribution" of ten dollars to the city before being let go. By the next winter, if not before, Lee had advanced to the rank of madam, as proprietor of a brothel at 133 North Wichita. That spring and summer, Dixie and several women in her establishment paid fines to the city. Police also brought in a batch of disturbers of the peace from her place on a Sunday night.

Being a successful madam required more than just good business sense and the skills of a coquette. A madam needed enough self-discipline not to fall victim to the lure of alcohol and narcotics, which were often abused by the city's working girls and their clients alike. A certain tolerance for danger and violence didn't hurt either. On one occasion, a client who'd spent several hours at Dixie's place returned and fired two bullets into one of Dixie's employees, identified as Nellie Moore. A physician who happened to be present removed the bullets from Moore.

Dixie occasionally faced bigger legal nuisances than monthly fines. In 1888, a grand jury indicted Dixie and eleven others on charges of prostitution. Grand jury testimony indicates that Dixie's house was considered a cut above the city's other brothels, which included the Paradise, Black and Tan and Little Georgia's, all located on or near Tremont Street in the city's most notorious red-light district. Other brothels operated along north Water Street and the Rock Island railroad tracks. The case never went to trial, but it shows how prevalent the supposedly forbidden activity was in the city.

In 1890, Dixie was sued by a woman who claimed that she had enticed her fourteen-year-old daughter to lead a "life a shame" before eventually turning the girl out, penniless, onto the street. Noting the amount of damages sought—the then astronomical sum of $101,035—and the fact that the plaintiff had filed two previous legal actions against Oppenheimer, the Eagle *implied* it was the nineteenth-century version of a nuisance lawsuit. The outcome of the lawsuit isn't known. But a few months later, criminal warrants were issued against Oppenheimer and a codefendant for allegedly receiving a girl under the age of eighteen into a "house of ill fame." The defendants each posted $700 bond.

By then, Dixie seems to have made friends in important places. Judge C.V. Reed dismissed the criminal charge on what was described as a technicality a few days later. The same year, Judge Reed tossed out another charge against Dixie's husband, Charles Oppenheimer—that of keeping a

public nuisance where liquor was illegally sold. The *Beacon* left little doubt in its coverage of the affair that something nefarious was going on. It noted that Charles Oppenheimer had worked closely with both his wife's attorney and the county attorney on behalf of Judge Reed in the recent Republican Party primary.

Dixie and Charles Oppenheimer wed in 1887. A University of Michigan graduate, Oppenheimer was a promising businessman in his thirties when he met Dixie. He had moved to Wichita to work as a salesman in a clothing store and later took over a cigar shop he named The Oppenheimer. Charley Oppenheimer was cultured, courteous and affable, but he was also known in sporting circles throughout the Midwest, having apparently been led astray by the wrong kind of friends. Oppenheimer fell in love with Dixie, besting numerous admirers for her hand. His parents tried to get him to leave her, offering money and other inducements, but to no avail. Early in their marriage, the couple reportedly departed Wichita to live in California for two years and then returned and built a handsome cottage just north of Dixie's luxurious brothel on Wichita Street. Some credited Oppenheimer with astutely managing Dixie's business so that her fortune grew through investments in real estate and government bonds.

Whether he deserves that accolade, Oppenheimer was definitely a presence in the family business. On the night Dixie's housekeeper was shot, Charley Oppenheimer ran after the man, firing his own gun, but the assailant got away down an alley.

Dixie may or may not have possessed the proverbial heart of gold attributed to members of her profession, but she definitely had a soft spot for children—and a stiff backbone to match. In the spring of 1894, two years after the shooting at Dixie's place, a child welfare worker tried to take away her adopted daughter, Ruth. According to the *Beacon*, the child had been born in Dixie's establishment, presumably to one of her soiled doves. The newspaper reported that Dixie had tried to adopt another child, from Kansas City, several years earlier, but it had been taken from her. In the present case, Dixie stated her desire to build a new home for Ruth in a respectable neighborhood, but residents of that area raised sufficient objections to kill the idea. An officer of the law was said to be ready to scoop up the child the next morning.

It didn't happen, although precisely what did occur remains unclear. A longer and more detailed account of the drama that appeared in the *Eagle*

reads as if dictated by the Oppenheimers or somebody in their camp. Ruth (according to the article) had actually been born eighteen months earlier, in Springfield, Missouri, to a young woman of good family and social connections, "the result of her mother's sin." The mother died two days later. The infant was left with a doctor who was supposed to send it to a foundling's institution in St. Louis. However, because Springfield was outside the jurisdiction covered by that charitable institution, the girl was returned to Springfield with no real prospects for the future. At that point, a friend of Charley Oppenheimer's suggested that the baby be given to Dixie, who'd often expressed a desire to adopt. The girl was brought to Wichita. Dixie hired a woman on the east side of the city to take care of her, bought a Jersey cow to provide fresh milk and arranged for all the other necessities of an infant.

That winter, the girl contracted a fever of the lung, and more doctors and nurses were employed to take care of her. Once recovered, the girl was brought to Dixie's house on Wichita Street. Dixie, smitten by the child, contracted for a house worth $5,000—a significant amount for the time—to be built and promised another $1,500 for its furnishings.

In response to the child welfare worker's intentions, contingency plans had supposedly been made to spirit Ruth out of Wichita and into the hands of trusted confederates of the Oppenheimers who lived in the countryside. It was also reported that should an attempt be made to remove the child, Dixie Lee would fight all the way to the U.S. Supreme Court. In the end, no attempt was made to seize Ruth, who was said to be sleeping comfortably in the private quarters of Dixie's mansion on Wichita Street.

One thing that both newspapers did agree on was that Dixie wanted to build Ruth a new home in a more genteel part of Wichita but was prevented by the genteel folk from doing so.

Not long after winning the battle over her adopted daughter, Dixie got caught up in two controversies that would make her even better known across the state and region. At the time, some Kansans were demanding that authorities enforce the state's laws against prostitution and the sale of liquor, which had been openly flaunted in Wichita. Reformers tended to belong to the Republican Party, while Democrats favored a more lenient approach, arguing that local authorities should regulate the matters according to sentiment in their communities. As a practical matter, the Democratic-leaning *Beacon* noted, the loss of revenue from these types of establishment would cripple city government.

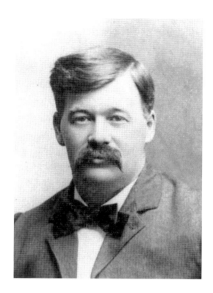

Sheriff Benjamin Royse, who tried and failed to put Dixie Lee out of business. *Sedgwick County Sheriff's Office.*

Sedgwick County sheriff Benjamin Royse, elected on the Republican ticket in 1894, set out to shut down Wichita's brothels and saloons. Meanwhile, Dixie or someone affiliated with her reportedly tried to use the city's police chief, Rufus Cone, to put a rival brothel owner named Kitty Paxton out of business. Paxton, recently arrived in town from Lincoln, Nebraska, was rumored to be thriving with girls imported from that city and to have set up a bordello at 321 East Douglas (current site of the Ruffin building) that rivaled or even surpassed Dixie's in splendor. Dixie and Paxton eventually worked out their differences, and by the spring of 1895, the city's saloons and brothels were back to operating as before, Republican Party leaders having lost their taste for the battle. But the disclosure that Dixie Lee had paid $400 to state Senator Ed O'Bryan of Wichita to act as some sort of intermediary on her behalf led to headlines and an investigation. "You go to hell!" O'Bryan screamed at a reporter who asked him about the payment.

Wichita was far from the only Kansas city where saloons and bawdy houses ran wide open, but it probably deserved its reputation as the leader in that respect. In March 1896, the *Topeka State Journal* newspaper reported that "all the saloons in Wichita are open and Dixie Lee, the most notorious women in Wichita's history, has returned from Kansas City with fifteen painted creatures and opened up business in full blast." A few days later, the headline over another article in the *Journal* referred to Wichita as "Dixie Leeville." The *Journal* reported that Dixie's sister, who'd joined her in Kansas, had been assured that the Wichita Street establishment would not be interfered with and that, in fact, all gambling houses, saloons and bordellos would be allowed to operate under a board of city police commissioners appointed by Governor Morrill at the request of Wichita residents. As another newspaper noted, the Topeka newspaper seemed determined "to make Dixie the notorious scarlet woman of Wichita a live issue in the coming election."

The only problem was that Dixie was no longer the scarlet woman of Wichita, at least not exclusively. In 1894, she established her primary residence in Kansas City and set up a brothel on Third Street, in a well-established red-light district. She continued to spend some time in Wichita but left the day-to-day operation of her Wichita brothel to others.

The marriage of Dixie and Charley was a troubled one, marked by fights, separations and reunions. Not long after moving to Kansas City, Dixie obtained a divorce and won custody of their daughter in a lengthy, bitter legal battle. The split unhinged Charley Oppenheimer. He wrote several letters to Dixie threatening to kill her if she did not give him money. In Wichita, he told a newspaper reporter that all he wanted was custody of their daughter.

On a Sunday afternoon in the winter of 1896, Oppenheimer went to Dixie's door in Kansas City armed with a pistol. He was turned away. Dixie wasn't unduly concerned until she heard from an old Wichita friend that Charley planned to return that night to finish the job. Dixie informed the Kansas City police, who stationed two detectives at her house. At 10:00 p.m., they saw a man climb over the back fence and run toward an open back door, revolver in hand. After catching and disarming Oppenheimer, police found a dagger, a bottle of morphine and suicide note in his pocket. Oppenheimer was taken to a hospital for a mental examination.

Less than a week later, he was back in Wichita and accused of threatening to kill Dixie's sister, who was running the bordello on Wichita Street. Police Chief Frank Burt called him in for questioning. Oppenheimer's response to the chief got him locked up for the night. He was released the next day after promising to leave town.

Back in Kansas City by the next spring, Oppenheimer learned that Dixie was romantically involved with a businessman and sometime politician named John O'Neill. Dixie again refused to see her ex-husband. Charley Oppenheimer and a friend wrote a bad check for twenty-five dollars and were arrested at Kansas City's Union Depot while trying to buy tickets to Texas. The two men were placed in the same cell.

At about 4:30 a.m. that morning, the friend was wakened by Oppenheimer's groaning. Oppenheimer had apparently concealed a vial of carbolic acid in his shoe. He drank two ounces of the poison, a popular though painful way to commit suicide during that era. He'd written two letters before taking the poison. One was to a rabbi, asking for a funeral according to rites of the Jewish faith. The other was to Dixie and O'Neill. "Farewell to you both," the note read. "It is for you to make a good woman out of the dear child and quit the disreputable business you are now in. If it had not been for

John Neil [*sic*] you would not have treated me as you have. This is the third time I have tried this, and it has become a mania with me, and this time I'll make sure of it. I hope when O'Neill and yourself awake at night you will remember how I looked after death." Oppenheimer closed by asking Dixie not to tell any lies about him and then asked God to bless her and Ruth.

As eventful as Dixie Lee's life was, it's frustrating for a biographer in one sense. With possibly an exception or two, no record of words spoken directly by her seems to have survived, nor a description of the woman. Other members of Wichita's underworld were regularly quoted in the newspapers or made their thoughts known in a courtroom or some other public forum. Dixie seems to have maintained a decorous discretion, which perhaps added to her allure.

Dixie Lee had two more battles to fight. In 1900, she filed an injunction in district court to prevent the City of Wichita from turning over part of Wichita Street to the Missouri Pacific Railroad. The railroad wanted to lay tracks down the street and build a new depot on west Douglas Avenue, near Dixie's property. Dixie claimed that the construction would damage her business, while the railroad said vehicles and pedestrians would still have access to Lee's property. The railroad was reportedly willing to buy Dixie's property, but not at the price she wanted.

The city's business leaders, believing a new depot was vital to the city's growth, held a special meeting and pledged to help the city in its legal battle if necessary. "Plainly speaking the people generally prefer the new depot to a disreputable resort," the *Beacon* reported. Despite being represented by lawyers from the firms of both County Attorney Sam Amidon and Governor W.E. Stanley, Dixie saw her injunction dismissed a few days later.

By January 1901, Dixie was suffering from a grave medical condition. The nature of her illness isn't known, but she traveled to Chicago for an operation to try to regain her health. It was not successful. She took a train to San Francisco, where her mother and other family members lived, and checked into a hospital. On January 8, she signed a will in which she left her home in Kansas City, diamond rings and other jewelry and government bonds to her daughter, Ruth, who was eight years old. She left her property in Wichita to her mother, brothers and sisters. O'Neill received furniture from the two brothels in Kansas City. Her entire estate was valued at about $150,000. She died in the San Francisco hospital five days later. "Notorious Dixie Lee Dead" was the headline in the *Eagle*. She was thirty-eight years old.

SPLITTING THE BLANKET

Marital woes were often the talk of early Wichita, and not just newspaper accounts of quarreling celebrity couples in faraway New York or Chicago. The breakups of Wichitans packed courtrooms and filled the local columns of newspapers to a degree unknown today, frequently accompanied by salacious allegations of adultery and other misconduct—even murder.

To a large extent, this was because there was no such thing as a no-fault divorce. In most cases, the wife (usually) or husband had to convince a judge that she or he was the aggrieved party. Proving blame required evidence. Newspapers of the era, unlike most today, were not squeamish about publishing it. A good example was the on-again, off-again divorce of Francis and John Goodyear. John owned a drugstore and the Hotel Goodyear, located at the corner of Douglas and Emporia Avenues. Francis, better known as Frankie, was the younger sister of his first wife, who had died more than a decade earlier. In 1893, Frankie petitioned for divorce alleging "extreme cruelty"—standard grounds of the day. She asked for $1,000 alimony, the household goods and attorney fees. John Goodyear did not contest the petition, saying he hoped Frankie would be granted a divorce "and thus let him free."

To his disappointment, his wife did not press the case. Instead, according to his lawyer, Frankie continued living at the Hotel Goodyear but apart from her husband, drawing court-ordered financial support from him on a regular basis. In retaliation, Goodyear filed court papers

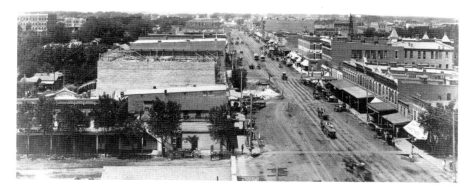

John Goodyear wanted to divorce his wife, but she refused to leave his hotel, seen in lower left of photograph. View is looking west on Douglas. *Jim Matson.*

accusing his wife of adultery with W.L. Johnson, a city council member from Wichita's Third Ward. Goodyear alleged that Frankie's infidelities had begun in the hotel three years earlier. Goodyear also alleged that his wife was guilty of visiting strange places and getting drunk with men he did not know.

As the trial approached, Goodyear sat in jail rather than pay his wife's support and attorney fees, as ordered by a judge. From his cell, Goodyear promised that when the case was heard he would present "rich, rare and racy testimony" that would make the Breckenridge-Pollard affair—a sex-and-politics scandal then playing out in Washington, D.C.—seem tame by comparison. When his day in court came, Goodyear produced numerous witnesses who'd seen suspicious behavior by his wife at the hotel, but none who had actually seen her violate her marriage vows. This is not to say the day lacked drama. Frankie testified that Goodyear had once come into her room, threatened to kill her and then fired five shots from a revolver into a bed. Goodyear claimed to have been shooting at some unruly neighborhood cats. Johnson acknowledged boarding at the hotel and patronizing Goodyear's drugstore. He denied any inappropriate behavior with Frankie. When Johnson claimed that Goodyear had admitted falsely accusing him to get at his wife, the two seemed briefly about to come to blows in the courtroom.

The next day, Judge C.V. Reed delivered his verdict: no divorce would be granted since neither party had "clean hands." Goodyear was freed from jail but far from happy. "I am the most persecuted man alive," he told a

newspaper reporter while making his way back to his hotel. "They not only sent me to jail, but now they want me to live with the wife who has brought shame and disgrace upon me."

It got worse. A few weeks later, Goodyear and two other men were arrested for selling liquor at the hotel in violation of Kansas's prohibition law. Frankie was believed to be the source of the allegations against the three men. Frankie then sued for divorce again, which John Goodyear probably welcomed, but she still refused to leave the Goodyear Hotel. In fact, she succeeded in having one of its employees arrested for trying to force her out.

John Goodyear wasn't going down without one more fight. He set a spy on Frankie. On a hot summer night in 1894, the informer let him know that Frankie had rendezvoused with Councilman Johnson at the Washington schoolhouse, located at Third and Cleveland, in Johnson's Third Ward. Goodyear hurried to the spot. He found that his wife and her paramour had moved on to to a nearby pasture. Goodyear pummeled Johnson, who ran before turning around and pointing a pistol at Goodyear. At least, that was Goodyear's story. As proof, Goodyear offered a bandaged finger he said he'd broken on Johnson's head. Johnson claimed that the battle in the pasture was as made up as his affair with Frankie.

In September of that year, Judge Reed finally granted the Goodyears a divorce, evidently deciding that he'd done all he could protecting the sanctity of that particular marriage. There was some expectation that the liquor charge against John Goodyear would disappear with the divorce finalized, but it was not to be: Goodyear wound up pleading guilty, was fined $200 and sentenced to sixty days in jail.*

The Goodyear case had its comedic aspects, but other domestic squabbles were deadly serious. Take the case of Irene Williamson, who divorced her first husband and then tried to send him to prison for the brutal murder of her second.

* Goodyear's legal troubles weren't over. In 1901, after being accused of statutory rape, the sixty-four-year-old Goodyear was shot in the backside by the brother of the fourteen-year-old alleged victim.

Williamson was in her early thirties, tall and slender, with dark hair, black eyes and an aquiline nose. She had never learned to read, a handicap that likely played in a role in the tragic events to come. Irene married a former soldier named Marion Williamson in Wichita. Their union produced a son, Norvel, but it was not a happy one overall. Mrs. Williamson complained that her husband didn't make a good living and boasted that she could find another man who would take better care of her. Mr. Williamson finally tired of the taunts and moved to a home for former soldiers in Leavenworth. Irene Williamson filed for divorce; her husband did not contest it.

Their son, by then a teenager, twice wrote to his father that he and his mother were broke. Marion Williamson traveled to Wichita intending to make some provision for his son's support. He ended up moving back after taking a job in the boiler rooms of the Carey and Manhattan Hotels. By then, Irene had married another former soldier, Henry Leonard, who ran a secondhand store on Douglas. Leonard had himself been divorced months earlier, not contesting his wife's charges of neglect and non-maintenance. He was about twenty years older than Irene.

For a while, Leonard seems to have appreciated his younger wife. He furnished their cottage at the corner of Lewis and Lawrence (now Broadway) Streets and amended an $5,000 insurance policy on his life to make Irene the beneficiary. But by November 1895, their relationship had soured. Leonard came home drunk one evening, threatening Norvel and ordering him and Irene to leave the cottage. Court testimony later showed that Leonard had spent much of the night drinking in another woman's room, up one flight of stairs from Douglas Avenue.

Norvel complained to his biological father of the situation. Marion said he had no right to interfere in another man's house but told his son to pass word to Irene that she could find him at the Maple Street bridge. That afternoon, an agitated Irene drove up to the bridge in a rented carriage and asked her ex-husband to get in. She crossed to the west side of the Arkansas River, parked the buggy and repeated what Norvel had said about the night before. She added that Henry Leonard had lost fifty dollars—apparently while gambling—and was likely to lose his home and store. Irene then pulled a piece of paper out of her pocket and asked her ex-husband to explain its contents. Marion said it looked like an insurance policy but told her to take it to a lawyer if she really wanted to know what was in it. Over the course of three murder trials, it was never established whether Irene understood that the policy covered accidental

The Carey Hotel, now the Eaton Place apartments, provided an alibi for murder defendant Marion Williamson. *Author's photo.*

and natural death but would be void in event of her husband's murder. Irene asked her ex-husband to suggest some way out of her troubles. When he said he could not, she replied, "Well, something must be done and done right away."

A horse and buggy driver stumbled over Harry Leonard's corpse before daylight the next morning, lying in an alley between Market and Lawrence. Leonard was covered in blood, his hands uplifted as if still trying to ward off blows. The scene suggested he had been beaten to death during a robbery since his pockets were turned out and empty. But Police Chief Charlie Burrows soon had a different theory of the case. In the backyard of Irene's house, about one and a half blocks away, officers found marks indicating that something heavy had been dragged through the dirt. Inside the house, officers discovered bloody garments, a hatchet and the life insurance policy on Leonard.

When Chief Burrows asked Mrs. Williamson where her husband was, she said she didn't know. Told of his murder, she blurted out, "I would not do a thing like that nor get anyone else to do it." Chief Burrows immediately formed an opinion that the two people responsible for Leonard's murder—Irene and her son—were standing before him.

Irene soon changed her story, possibly helped by prompting from Sheriff Benjamin Royse, who pointed out that a man's strength would have been needed to drag away the body. She now said that Harry Leonard had been lying in bed when her ex-husband, Marion, entered the home and beat him to death with a piece of gas pipe. Marion had then put a hat and coat on the body and carried it away. Norvel, with additional prompting from the sheriff, backed his mother's story, adding that he'd once heard his father threaten Leonard's life.

Authorities charged all three family members—Irene, Marion and Norvel—with murder. In their separate jail cells, the family members turned on one another in interviews with a newspaper reporter. Marion referred to Irene as a "she devil" and blamed her for drawing their son into a plot to murder Leonard for money. He speculated that she intended to make it look like Leonard had been killed during a robbery but so "botched" the operation that throwing the blame on him was her only option. Irene claimed that her ex-husband killed Leonard because she would not return to him. Irene could not explain why neither she nor her son reported the slaying, beyond the fact that they were "so scared we didn't know what to do." Norvel was described as looking at least eighteen years old, although

he gave his age as fourteen. He said his mother had slept in his room on the night of the murder because his stepfather was drunk. His father showed up and hit Leonard in the head "a hundred times" with a piece of gas pipe. His father carried out the body, made his mother help clean up the scene and then "told us he would kill us if we told anybody." Even allowing for the tendency of newspapers of that era to sensationalize, it was pretty scandalous stuff.

The Williamsons' preliminary hearing and trials that winter drew big crowds, including some of the town's most prominent women, probably because of the novelty of a female defendant. Irene dressed neatly for her court appearances and was at various times described as smiling, appearing nervous or seemingly not understanding the seriousness of the proceedings. She was supported in court by her sister and her family, who lived in Wichita and admitted to being shaken by the attention.

Marion was a stout man, with an open countenance and friendly blue eyes. He maintained that he was completely innocent and indeed ignorant of anything having to do with the crime. Well-liked in the community, his innocence was believed by many until a witness at the preliminary hearing testified about seeing him in the buggy with his ex-wife on the day before Leonard's body was found. All three defendants were bound over for trials to take place the next year.

Irene stood trial first. The jury could not reach a verdict after two days and a mistrial was declared, although it was understood that she would be retried. While community opinion seemed to lean toward a verdict of guilty, attorneys not directly involved in the trial pointed out that a key part of the state's case—that Mrs. Williamson believed the insurance policy would be paid in the event of murder—had not been proven.

Marion's trial began the next day. He produced witnesses who swore that he had been working at the Carey Hotel around the time the murder occurred. The testimony of a former resident of the soldiers' home in Lawrence—that Williamson tried to hire him to kill someone—was colorful but not particularly credible. The jury deliberated through the night, returning a verdict of not guilty the next morning. "There is surely a God in Israel!" Williamson exclaimed as the verdict was read and spectators cheered. Then he wept and shook the hand of each jury member. In court, the estrangement between Williamson, his son and ex-wife appeared complete.

A jury convicted Irene of second-degree murder at her second trial. She was sentenced to thirty years in the penitentiary. She received a gubernatorial

pardon in 1909 due to illness. Her whereabouts after that aren't known. The biggest hole in Irene's defense was her inability to account for her whereabouts during several hours the day her husband was killed. The way in which Harry Leonard's murder was carried out seemed to require the strength of a man. Had Irene used the time in question to recruit one?

Or was there one in her own home? Her son was comparable in size to a man. Nevertheless, the murder charge against him was dropped soon after his mother's conviction. He was a minor at the time of the murder and presumed to be under her control.

OPIUM AND MURDER

Wichita's first war on drugs differed from those that followed in one key respect: the narcotics in question—opium and derivatives such as morphine—were perfectly legal in the nineteenth century. That left police in a tricky position when they decided to do something about the drugs, which does not seem to have been very often.

In January 1896, for instance, the *Eagle* ran a lengthy article detailing a visit to an opium den by one of its reporters. The article described how the reporter gained entrance through the alley door of a Chinese laundry; the price he was quoted, twenty-five cents for "little smoke" or a half-dollar "goodee smoke"; and much about the proprietor, Charley Chung, described as a "heathen Chinese" aided by his American-born wife. The paper employed numerous misspellings to mock Chung's accented English.

Although the reporter didn't sample the product, he had apparently done enough research to describe its effects on a user. "Every puff is a fairy dream and in a few minutes he is in a land of delights. All the pleasures of the world pass in review before him." No wonder it was popular. However, the article went on to catalogue the results of regular use, which was said to turn a man into a wasted shell of himself, without morals or any ambition save obtaining his next "hit on the pipe." The report estimated that there were about one hundred opium "fiends" in the city, including several young men from good families, a police officer and "prostitutes of the lowest order." The den's location, on South Lawrence (now Broadway) a half block off Douglas

Opium was available without a prescription in many forms in early Wichita, from these patent medicines to opium dens. *Wichita–Sedgwick County Historical Museum display.*

Avenue, the city's main thoroughfare, made it unlikely that city officials were unaware of its existence.

The day after the article's appearance, the president of the Metropolitan Police Commission, Judge D.A. McCanless, ordered officers to shut down Chung's opium den. A second opium joint, catering especially to women, was said to be opening soon. "You pull the joint and I will find a law to prosecute them under," McCanless said. The newspaper heartedly endorsed the idea, noting that many people thought "the Chinaman" and his wife should be run out of town.

Chung, however, knew enough about the legal system in his adopted country to visit the police chief, Charlie Burrows, who admitted there were no grounds to close the den. The chief said opium dens had operated legally in Wichita for years. The chief did suggest that Chung leave town or risk being hanged by a mob. Chung declined. Meanwhile, a frequenter of Chung's joint offered the *Eagle* reporter a free puff—"a genuine case of tampering with the honesty of the press," the newspaper huffed.

It wasn't until two months later that the next police chief, Frank Burt, found a way to put the opium operation out of business. Burt had Chung's wife arrested on charges of drunkenness. She reportedly tattled on her husband in exchange for being let out of jail, alleging among other things that Chung had threatened to kill Burt for taking away one of his opium pipes. Police raided the den and found a stash of knives, clubs and other weapons. Chung and his wife reportedly moved to Wellington.

Then, as now, there were people who believed that the use of drugs is a victimless crime and should not be prohibited by the government. But it can't be denied that opium went hand in hand with criminal conduct by some users. Usually, it was just one factor, a kind of enabling agent that allowed somebody motivated by anger, greed, lust or revenge to act on the impulse.

One such case unfolded one night in the spring of 1897 when a young woman and two male companions came upon a gruesome sight along North Water Street. The discovery was a man lying across a sidetrack of the Missouri Pacific Railroad. As the trio approached, they saw an object that looked like a two-foot-long metal rod or pipe sticking out of the back of the man's head. Blood and brains oozed from the wound as the man gasped for breath. The woman ran to a nearby house to tell what she'd seen while the men headed south to summon a policeman.

The first physician at the scene, Dr. J.H. Fordyce, pulled the metal object out of the victim's head. It was a piece of three-quarters-inch gas pipe that had been thrust into the base of the victim's brain with enough force to travel four inches further into the interior. Slightly angled, it nearly poked through the right temple. The victim was put on a stretcher and gently moved to a horse-drawn wagon, which conveyed him to police headquarters. There his wounds were dressed before he was moved again, to his brother-in-law's home on West Douglas Avenue. He was given virtually no chance of survival.

The stricken man was recognized as L.J. White, who lived about two blocks north of where the assault occurred. Although he was fairly new to the city, acquaintances described him as an exemplary citizen. He had served as a law officer for seventeen years in Montezuma, Iowa, including two terms as sheriff. He'd resigned for health reasons and moved to Wichita about two years earlier. In Wichita, he ran a restaurant on West Douglas Avenue that he'd shut down shortly before the assault. He was known to carry large sums on money, which led to speculation that robbery motivated the attack. White

was in his early fifties, a member of several lodges, married and the father of three sons. His wife had been away visiting her mother in Udall, Kansas, when the crime occurred. She caught a train back to Wichita as soon as a telegraph reached her.

Police didn't have to look far for a suspect. Within an hour of White's discovery, Officer Harry Sutton arrested Art and Mary Ingram, who lived less than twenty yards from the pool of blood in which White was found. Art Ingram made no attempt to hide his involvement but seemed befuddled. "My God! Did I do that?" he said upon seeing White. "He is an old man."

Ingram, twenty-four, had been in the city jail on minor charges a score of times and once on the not-so-minor charge of the statutory rape of a fifteen-year-old. He was, however, quickly cleared of that charge and instead listed as a witness against three others. Ingram was known to be a habitual user of opium. He was also a sometime prizefighter. He'd won a thrilling victory in the ring a few years earlier, stopping his opponent in the seventh round of a scheduled twenty-rounder. More recently, he'd lost a fight and the chance for fifty dollars, perhaps because of his opium addiction.

His wife, Mary, cooked for the couple's landlord, Mrs. Morris, who ran a bordello in another house on the same property. Mrs. Morris's establishment faced Water Street, while the Ingrams' home sat alongside the Missouri Pacific railroad tracks.

The other occupant of the property was the woman who discovered the stricken man. Nina Raymond was known as a "girl about town" and lived in a cottage behind Mrs. Morris's house. As it turns out, Nina and her friends had been smoking "hop," as opium was called, at a Chinese laundry on East Douglas before finding White. At least one of them had previously shared a pipe with Art Ingram.

On the night of the Ingrams' arrests, some friends of the victim gathered outside the city jail while two of his sons viewed their unconscious father inside. Fearing mob violence, police slipped the Ingrams out of the city jail and took them to the county jail. In what was then a routine occurrence, a reporter for the *Eagle* was given the opportunity to interview the prisoners. Art at first refused to answer any questions, behaving as if he was under the effect of opium. But as the narcotic wore off, he gave his version of events. He'd been sitting in his kitchen, he said, when someone knocked on a door in the rear of the house. His wife answered and found a man standing there. She slammed the door in his face. The man walked around to the front door, twice knocking and having the door closed in his face by Mary. Although some men in Ingram's place would have entertained suspicions at

this point, Art always maintained that he believed a stranger was trying to force his way in. Art said he decided to call a policeman. Leaving the house to find a telephone, he encountered the would-be intruder on Water Street. Ingram said the man threw a stone at him, striking him the chest and almost knocking him over. Ingram ran back into his house and grabbed the piece of pipe that he had been using as a poker for the stove. When he came back outside, Ingram said, the man tossed another stone at him but missed. Ingram threw the pipe at the man to scare him off. Citing the darkness, he claimed to be unaware that he'd hit anyone with it.

Other evidence suggested that the victim, White, had been struck on the face first. According to doctors, he had suffered a broken nose and a deep cut over one eye. At a preliminary hearing for the Ingrams, White's family doctor said he believed White was lying down when struck with the piece of iron pipe.

When Art talked to lawmen that night, he told Rufus Cone—now Sedgwick County sheriff—that he hoped White would recover. He complained to Officer Sutton that fate seemed to be conspiring against him, as he'd just managed to get a good job. Mary's conversations at the jail were of a different nature. She asked the *Eagle* reporter for whiskey and offered to reimburse him if he would bring her some. She also gave the reporter a key to her house, asking him to blow out a lantern and let her cat out.

After Sheriff Cone refused to grant Art Ingram's request that the couple be allowed to share the same cell, Ingram kissed his wife goodnight. "Keep your mouth shut," was her parting advice. That he didn't would come back to haunt him. White, meanwhile, died forty-eight hours after he was discovered, having never regained consciousness.

The Ingrams' preliminary hearing, ten days later, was moved to a bigger courtroom to accommodate the crowd of fascinated onlookers, who at one point pushed through the railing around the stenographer and other court personnel. By day's end, all in the courtroom knew that the victim— heretofore a paragon of civic virtue—had been sleeping with Mary Ingram as well as Nina Raymond, part of the trio who'd found his body.

Mary took her own advice and refused to answer questions on that subject during her testimony. But the tiny, vivacious Raymond had no such compunctions. She testified that Mary and White had sex, presumably for money, when Art was at work or off in town on his own. Raymond told the court that White had first been her customer at Mrs. Morris's place.

Sometimes, she said, he seemed afraid someone would catch him in the act. At other times—generally when drinking—he displayed no concern. Despite White's payments to her, Raymond said she grew bored with White and decided to pawn him off on Mary. Mary hesitated at their first meeting, but Raymond said White wound up visiting her half a dozen times. White usually showed up in in the afternoon, although he might come over in the evening if Art Ingram washed up after work and went into town on his own. In fact, White had a date to see Mary on the night he was attacked. He always brought a bottle with him and insisted that the women join him in a drink. Nina would tilt the bottle to her lips and pretend to drink, but Mary enjoyed whiskey and beer.

Kittie Miller, another of Mrs. Morris's girls, testified that she'd seen Mary at the bordello the night of the assault. Mary complained that she was lonesome. Art arrived at the property and appeared to be under the influence of some intoxicating substance. When Nina rushed in a little later, sounding the alarm about a man lying on the track, Kittie Miller, Mrs. Morris and others ran over to see. Mary remained on the other side of a rickety fence from where the body lay. Later, Mary walked to Mrs. Morris's house and tossed a silver dollar at the madam. "Here, take this. I don't want it," she said. "It was the last dollar I got from White."

Despite a motion by Mary's attorney that the charge against her be dismissed, the judge found enough evidence at the preliminary hearing to bound husband and wife over for trial in two months. About a week before that event, the sheriff and prosecuting attorney Sam Amidon paid a call to Mary in jail. Amidon, assuring Mary that he was talking to her as a friend, advised her to be careful going forward. Sheriff Cone was blunter, saying the "old man"—presumably a reference to the presiding judge—would send her to jail for forty years.

At the trial, which lasted four days, Mary told jurors that she had found the stone White threw at her husband but lost it in the confusion of being arrested. Asked about her background, she said she'd been divorced once before and had gone to the Oklahoma Territory south of Wichita to live the "sporting" life. She'd met Art in Enid, and he'd become her solid fellow. Moving to Wichita, she'd worked as a chambermaid at the Occidental Hotel and had been arrested several times for cohabitation, a charge police sometimes found easier to prove than prostitution.

Part of the Ingrams' defense was that White had tried to force his way into their house by kicking in the door. For the defense, an employee of the Missouri Pacific testified that he'd watched from the cupola of a caboose

as White knocked and then kicked at the Ingram's door, finally being let in by a woman. But this was hours before the fatal encounter. Another witness, a kind of character witness for Art, testified that the defendant had been working for a foundry over the winter and taking treatment for his morphine habit. Art's father also took the stand, saying he tried to get his son to leave his wife on several occasions. "If I thought my boy was trying to protect the honor of that old —, I would not ask the jury to acquit him," he said.

Finally, it was Art's turn in the witness box. He said he'd been born in Wamego, Kansas, and lived in Wichita most of his life. He'd met Mary while tending bar in Enid, Oklahoma, returned with her to Wichita and been arrested for lewdly abiding with her there, serving a jail sentence rather than paying a fine. The police chief at the time agreed to let him out if Ingram would move to Colorado, which he did after marrying Mary. But his health was poor in that state, and he returned to Wichita. Questioned by his attorney, he said he hadn't known of any relationship between his wife and the dead man.

The damage to Mary's reputation done, prosecuting attorney Amidon asked the court to dismiss the charge against her before the case went to the jury. Amidon and O.H. Bentley, the defense attorney, made the lengthy closing arguments customary of the time. Amidon caused the Ingrams to wince as he described their lifestyle, while Bentley portrayed Art as a man simply defending his wife and home.

Jurors deliberated into the early morning. Nine of the all-male jurors initially argued that Ingram was guilty of second-degree murder, but three held out for the lesser charge of first-degree manslaughter and eventually persuaded the others. Ingram was sentenced to ten years in the state penitentiary.

The streak of bad luck that Ingram complained of continued. In the weeks leading up to a hearing on his motion for a new trial, he'd asked a friend to raise money to bring a witness he believed could clear him from St. Louis. The friend succeeded in raising thirty dollars, only to drink and gamble it away.

Before he was sent to the state prison in Lansing, Ingram lamented that he'd still be a free man if only he'd refused to testify. He now seemed clearer about exactly what transpired on that fateful night, saying he had mistaken White for one of the railroad employees that he'd been informed were

"laying for me." The cause of that friction was not specified. The summer after his conviction, he was covered in boils and sores caused by medicine he was taking to kick his morphine habit.

As it turns out, Ingram's time in prison was relatively short. He was paroled in 1902 after lawyer Bentley got hundreds of Wichitans to sign a petition asking Governor Stanley to set him free. The time behind bars forced him to kick his drug habit, for which he was thankful. He regained the weight he'd lost under its influence and once again resembled the athlete of prior years.

Ingram returned to Wichita and found a job working in a foundry. There is no mention of a reunion with his wife.

TREMONT STREET

Here day and night women disport themselves and liquor flows freely, the sounds of maudlin laughter and vile language broken only by the popping of wine, champagne and beer corks.
—the Eagle, *October 28, 1909*

*L*ook at a map of Wichita today and you won't find Tremont Street. In its time, though, it was one of the city's best-known thoroughfares. Indeed, Tremont was notorious across the Southwest for commercialized vice—prostitution, liquor and gambling—plus the usual array of felonies and misdemeanors associated with those pursuits.

Along "The Row," as the liveliest section of Tremont was called, working girls sat in front rooms with curtains pulled open, lazily puffing on cigarettes while clad in kimonos, pantaloons or other scandalous attire. If a potential customer still didn't get the hint, a gentle tap on the window might do the trick. The better class of brothels—the so-called resorts—featured a piano player and well-stocked bar in addition to the main attraction. Other houses of prostitution were little more than shanties.

Tremont was never Wichita's only den of iniquity. But it was the most concentrated source of the city's "unholy trinity"—sex, booze and gambling—in the early 1900s.* Many people undoubtedly enjoyed themselves, and a few got rich there. But the street took a frightful toll on some of its denizens, who brawled and stole from one another as well

* The phrase comes from the *Girard (KS) Press* but well applies to Wichita.

as visitors. Suicides, attempted suicides, disease and drug addiction ran rampant; violence was the norm.

City officials regularly pledged to clean up Tremont. But just as many were willing to look the other way or even take a cut of the action, which explains why Tremont enjoyed a long, lusty, boozy, bloody run.

Tremont Street sat where South St. Francis Street is located today. The Row ran south from Douglas Avenue for five or six blocks, through where Intrust Bank Arena now stands to the vicinity of Kellogg. Formerly known as Fourth Avenue, the street already enjoyed a bad reputation before it was renamed Tremont in 1899.

Not long after, as if to signal that nothing had changed, a vicious knife fight broke out when one of Tremont's working girls enticed a man named Butler into her room. The woman's live-in boyfriend, a noted Tremont street tough named Glaman, returned a few minutes later. He started a brawl that spilled out of the house into the backyard. Glaman stabbed Butler in the left lung. With air and blood rushing out of his chest, Butler staggered six blocks, finally collapsing in a sand pit near the Kellogg railroad crossing. Police arrested Glaman in the city's packinghouse district with morphine and two silver dollars in his pockets. He claimed self-defense.

The working girls of Tremont Street approached life with a mix of bravado and bad judgment. Maggie Plymell was latching the screen door of her resort at 219 Tremont against an unwanted visitor one night in 1909 when the man suddenly pulled out a revolver and fired, sending two .44-caliber bullets through her dress skirt. "I did not care for the dress skirt for it was an old one," Plymell cooly told a newspaperman afterward, "but if he had shot holes through the new petticoat I had on, I think I should have had him arrested." Liza Logan, a Tremont habitué known for her "scintillating eyes and willowy figure," faked a severe stomach illness after being arrested for larceny. Moved from jail to the hospital, she slipped out and down the fire escape as soon as nurses went to see about another patient. (Logan also worked as a cook for the city's best-known underworld figure, John Callahan.)

Not surprisingly, some gave in to despair, usually after reversals in love. Millie Light, a pretty twenty-two-year-old, died after drinking carbolic acid at 301 Tremont in 1906. "Dear Sweetheart," she wrote in a farewell note, "I know that that in death you will forgive me. No girl will ever love you

as I have. Goodbye forever. Mille." A woman named May Wilson drank a two-ounce bottle of laudanum with the same purpose in mind in 1901 while living in the White Elephant boardinghouse just south of the Carey Hotel (now the Eaton Place apartments). Only the quick appearance of a physician with a stomach pump saved her. Wilson was said to be despondent over the attention her boyfriend paid to another woman while she absented herself from the city at the request of police.

Other female residents were ready to fight for their men. One summer night in 1906, Maggie "Cocaine Kate" Green was accosted by another working girl just south of the Carey over a man known to both of them. Green responded with a flurry of punches that earned her a twenty-five-dollar fine. "You'd just as well make it $125, judge," Maggie said, "cause you won't get nothin' no how." Sadly, the spirited Green was gone the next spring, overdosing on a mixture of alcohol and her namesake drug. "She just took a little too much junk," a fellow inhabitant of the house at 232 Tremont said.

Smallpox, diphtheria, dropsy and typhoid fever all visited the inhabitants of Tremont. (Poor sanitary conditions contributed to ill health in many other parts of the community as well.) It's not known what disease Martha Pliler contracted, but a more pitiful story than hers is hard to imagine. Pliler had left her husband in Preston, Kansas, claiming cruel treatment, and drifted to 309 Tremont to make a living. Coming down with a serious illness a few months later, she begged to be taken home to her family before dying. The city's commissioner of the poor bought her a train ticket to Preston. At the Preston depot, her husband refused to see her. Her children—aged one, two and seven—were allowed to view their mother from a distance but not touch her. Her sister-in-law spoke to her for a few minutes. Other relatives refused to come to the station at all. Pliler returned to Wichita to die. She was twenty-six.

Tremont Street had a "king," Martin R. Clark, who owned dozens of properties along The Row. Clark was a Pennsylvania native and Civil War veteran who'd come to Sedgwick County in 1871 and eventually acquired much of the land on Tremont between William and Lewis Streets. Clark didn't bootleg, run brothels or operate craps games himself, but he never let a little thing like a police record stop him from renting to anyone who did. The *Beacon* noted that Clark "rented shacks at an enormous profit, principally to questionable persons. He was a hard collector who scarcely

ever lost any rents. He never erected a good house and never repaired an old one….Even his own residence was not improved since the day it was built, some thirty-three years ago."

Clark sold the Santa Fe Railway much of the property on which it built a new freight house on Tremont. Initially leery of putting the money from the sale in a bank, he secreted it away in his house a few streets from The Row. Maybe for that reason he was the target of at least one robbery conspiracy, which was intercepted by the police chief (who discovered one of his own officers involved).

Clark could be a nice guy—he provided a free bed for poor Martha Pliler as she lay dying—but he also grabbed a hammer to attack a man apparently guilty of nothing more than performing maintenance work on Clark's properties.

After Clark's death, his son, Lewis, returned to Wichita. The younger Clark, a plumber, seemed almost embarrassed by his inheritance and promised to clean up the Row. His father's estate was valued at $170,000, about $3.4 million today. The younger Clark twice called the police on women who rapped on windows as he walked by.

The police department's matron, Mrs. Ella Glenn Shields, acted as a combination welfare worker and undercover agent along Tremont. On one chaotic day in the summer of 1902, Shields tried to remove children from two families who lived across the street from each other on grounds that both youngsters were being "thrown into evil associations." The father of the first family produced a butcher's knife before being disarmed. The mother of the second brandished a revolver and then disappeared with her young son after promising to bring him in on her own.

The next year, the police matron ran a sting on the Aherne Pharmacy at the corner of Tremont and Douglas. Shields had heard that prostitutes were sending children to buy cocaine and morphine from the pharmacy in violation of a 1901 city ordinance that required a doctor's prescription for the narcotics. She confirmed the rumors by sending two nine-year-olds who lived on Tremont to make purchases.

The next year, Shields busted Charlie Sing for selling a substance called "Ishta" out of his restaurant on Waterman, just off Tremont. While many of Tremont's female residents used cocaine and morphine, their "peculiar actions" in recent months led Shields to believe that another type of drug was involved. She traced it back to Sing's place, where after lunch Tremont's

working girls would roll up and smoke cigarettes with tobacco and a pinch of Ishta in them.

Shields sent a Tremont regular to Sing's to get some of the stuff, which turned out to be a dark brown, pulverized substance. Its exact composition wasn't known, but it was thought to contain both morphine and opium.

It was also Shields who came to the aid of Mrs. Pliler, getting her medical treatment, the train ticket to Preston and donations of clothing and food after her return. Shields was said to be "amazed at the coldness of those who had turned her away." When the matron visited Mrs. Pliler, the woman looked at the donated items, turned her head to the wall and moaned.

Tremont Street provides an interesting perspective on race relations in that period of Wichita. White and black citizens fraternized there regularly, if not on an equal basis. African Americans worked in white-owned bordellos as maids, porters and piano players. Some ran their own establishments as well, as Carrie Nealey did at 310 Tremont and Ada Kelley did at the corner of Tremont and Watermen. Like their white counterparts, they were periodically raided and had to pay fines of $25 to $50 in Police Court (their girls were charged $5 to $10 each). That white men made up some of their clientele in an era of segregation can be seen by cases like that of a prominent businessman who had his pocket picked of $20 on Tremont in 1914. "To complicate matters more than usual, it developed that the occupant of the resort was a colored woman," the *Eagle* reported. Police got the man's money back and complied with his wish not to be identified in the newspaper. It wasn't an isolated incident. One of Nealey's girls, Sadie Smith, was accused of swiping $140 from a man from a neighboring town who came to Wichita "in search of adventure." Smith admitted going through the man's pockets but denied that she took that much.

The black working girls of Tremont were victimized, too. In 1906, a black woman named Aggie Gilbert had her throat slit from ear to ear in front of 237 Tremont, surviving only because the cut was not deep. Her assailant escaped. A few years later, a black female resident of Tremont stabbed a white man who kicked in her door. He was arrested but she was not.

Tremont also boasted Wichita's largest colony of Mexican immigrants, plus a smattering of immigrants from Europe and the Middle East. Mexicans (and those born in Mexico's former territory of Texas) had been part of Wichita since the cattle-driving days. By the time Tremont had assumed its role as a wide-open vice district, they labored on railroads and in the

city's meatpacking plants. There wasn't always enough work to go around, or at least not enough for the tastes of local authorities. Police periodically hauled in groups of Hispanic men from Tremont on charges of vagrancy, once marching twenty of them to city hall on Main Street (now home of the Sedgwick County Historical Museum) and lining them up outside. Those who couldn't prove they were employed were ordered to leave town. The officers had actually gone to Tremont looking for a bootlegging operation but, finding none, decided not to waste a trip.

The city's Hispanic community tended to keep to itself, perhaps because of a language barrier. Police found them unable or unwilling to answer questions about crimes committed in their midst. The newspapers portrayed them in mysterious terms, crediting them with "vendettas" and other "Latin" behavior. In January 1909, one of the best-known members of the city's Hispanic community was charged with murder: Ascension "Big John" Reynoso, foreman of the Mexican workers at the Dold meatpacking plant. The killing took place outside a chili parlor at 326 Tremont that the victim's brother owned. It was first ascribed to a feud between the victim and suspect's younger brother over a sixteen-year-old Syrian girl, but police never uncovered a clear motive. "It is said by those who are familiar with the Mexicans that they have but one way of dealing with those that incur their hatred, and that is to kill them," the *Eagle* intoned darkly. "For that reason most of them are afraid to talk freely or to testify in court against a fellow member of their race, for fear of the assassin's knife."

The next month, after Reynoso's younger brother Juan also was charged in the case, four men attacked and beat Liza Logan on Tremont and then pelted her house with stones, allegedly for refusing to provide an alibi for him. Police Chief O.C. Emery ordered his officers to arrest any Mexican found on Tremont. Both Reynoso brothers were eventually convicted of second-degree murder (with the help of testimony from Mexicans) and sentenced to prison.

Police hired what they called a "special policeman of Mexican blood," L.M. Tardeen, to help keep peace on Tremont. Unfortunately, Tardeen lost his badge after shooting his own brother-in-law in a domestic squabble.

The Hispanic residents of Tremont seemed to shy away from prostitution; gambling and liquor were the usual grounds for their arrests. An exception was Jose Zaragoza, who in 1912 was accused of being a "white slaver"—taking two white Wichita women to the Mexican work camps in Kansas, Oklahoma, Texas and Mexico.

In 1914, a double homicide on Tremont sparked speculation that it was somehow connected to the revolution then underway in Mexico. Jose Zaragosa was called out of his barbershop one night that summer by someone who pumped four .38-caliber shells into his chest.* A cousin of the mortally wounded Zaragosa followed after the gunman and was killed as well. Some believed that Zaragosa had been targeted over his support for Pancho Villa, then trying to overthrow President Huerta of Mexico. Zaragosa, who spoke English fluently, had been quoted by the *Eagle* a few months earlier saying that he wished he could go to Mexico "so we could help the United States kill him [Huerta]. Viva La Villa!" The suspected gunman, Pedro Leis, was described as a "noted Mexican bandit" with seven killings to his name. Some Mexicans in Wichita believed that he represented the Huerta government "as a slayer of Villa sympathizers in America." He was never captured in connection with the two Wichita killings.

In truth, anyone who lived or ventured onto Tremont was at risk. Stories of out-of-town men alighting at one of the city's train depots, making their way to Tremont and finding themselves poorer for the experience were legion. "I admit I'm half drunk but I've got sense enough left to know when I've been robbed," a traveling salesman told police after being arrested for public intoxication at 235 Tremont. He lost the sum of $14.50. But the crime that brought the most attention to Tremont—and seems to have sparked the first of many efforts to shut it down—was the shooting of William Flynn.

Flynn was in his early thirties, a tall, good-looking gambler and former racehorse owner. The man who shot him, Ralph Bain, ran the Santa Fe Hotel, which sat across the railroad tracks from the terminal of the same name. Bain was also a big man, a married father of three, and said to be bad drunk who held a grudge. On an evening in September 1903, the two spent several hours drinking and gambling at the Royal Saloon on West Douglas, which ostensibly operated as a restaurant. Bain lost most of eighty dollars at roulette while Flynn played faro. After engaging in what seemed like good-natured banter over "who was the better man," Flynn and Bain took a carriage together to Inez Miller's resort at 313 and 315 Tremont.

Miller's place was one of the city's classier brothels, with eight rooms and two parlors, one set up as a bar. Flynn was Miller's paramour and, according to one report, her pimp; she claimed to have given him a diamond ring to

* Not the Jose Zaragoza arrested on white slaving charges. The barber Jose Zaragosa was described as well-educated man in his early thirties who died leaving a wife and young child.

wear and horse and buggy to drive. Miller knew Bain, too. As the two men were drinking with some of Miller's girls, Bain took out his gun, a .44-caliber Colt revolver, and threatened to shoot out the lights if some music wasn't forthcoming. "Put your gun up and let's have a good time," Flynn told him. "I'm going to shoot you," Bain replied. Miller, thinking Bain was joking, stepped between the men and told Bain to "shoot me. I'm the biggest." Bain pushed her aside and shot Flynn through the chest. Flynn cried out, wheeled and ran out of Miller's place. Moments later, Flynn burst into the resort next door, Gertrude's, and asked the owner to telephone for a doctor. He collapsed in a chair and predicted, correctly, that he was about to die. Bain, meanwhile, caught a hack to Jack Eckert's restaurant at Douglas and Santa Fe, ate supper and went home to bed.

Bain's trial shined a light on a side of Wichita that many residents probably didn't know existed. One witness for the prosecution testified that she hadn't indulged in any morphine on the evening in question, as would normally be the case, but had consumed some whiskey. Another identified himself as an electrician by trade, with a sideline in slot machines. The hack driver said he'd been arrested for beating his wife the day before he married her, while other witnesses confessed to arrests for bootlegging and assault. One had slept with the defendant; yet another swore that Inez Miller threatened to kill her if she gave the wrong testimony. While sequestered in a nearby courtroom, witnesses from Tremont were reported to have conducted a "burlesque" trial of their own, complete with a pimp as judge, prostitutes serving as jury and a willing county official as defendant.

Bain's hope for acquittal hinged on his claim of self-defense. Under close questioning, Inez Miller acknowledged that she'd given a small revolver to Flynn before he was shot. Flynn apparently tossed it away after he was shot. A defense witness claimed that the dying Flynn begged Miller to get revenge on Bain, saying, "I want you to get my gun and not let anyone know that I had a gun, and I want you to get even with Bain if you can."

In closing arguments, one of Bain's attorneys said, in effect, that what happened in a brothel stayed in a brothel; there had "never been a man convicted of murder inside a house of prostitution." But prosecutor Otto Eickstein asked jurors to consider why Bain's defense had focused on the character of Inez Miller rather than that of the defendant. "Shall a man go unpunished because a woman—possibly the only one sober enough to intelligently describe the scene—is a prostitute? Aye, she has fallen down

to the bitterest depths of hell. She has disobeyed the commandments, she has sinned against God and herself, but does the accused stand in robes of white? It is just such men as he that makes it possible for women of her stamp to exist." Miller, he added, "has a heart in her as well as any woman."

Jurors deliberated twenty-six hours before acquitting Bain. Three weeks later, he was arrested after allegedly assaulting his wife and an employee of the Santa Fe Hotel. Bain's wife, Mattie, who had stood by him during the trial, filed for divorce after catching him having sex with a woman—identified as a witness in Bain's murder trial—in the hotel. County Attorney Eckstein announced that an unspecified

County Attorney Otto Eckstein, who unsuccessfully prosecuted a murder in one of Tremont Street's brothels. *Sedgwick County District Attorney.*

number of "Tremont Street witnesses" who'd testified in Bain's behalf had been ordered to leave Wichita within forty-eight hours.

That Sunday, a minister at the Plymouth Congregational Church preached a sermon called "The Damnation and Salvation of Wichita: The Flynn Murder Case." "Wichita is afflicted with cancer," the preacher said. "It is as a cesspool uncovered in a beautiful lawn." There were two remedies possible: an "army" of police to enforce the law or an effort to infect "the whole municipality with a sentiment for purity and righteousness."

A few months after Flynn's shooting, residents of Tremont Street south of Kellogg petitioned the city to change the name of their end of the street "based on the unsavory character of a number of residents on the down-town portion of the street." McLean Avenue (Ben McLean was mayor at the time) was suggested but not adopted. In 1905, Mayor Finlay Ross launched the first official cleanup of Tremont. His motion to close down its houses of prostitution won unanimous support from the city council, but the reform effort seems to have quickly run out of steam judging by numerous police calls to the area that summer. In November, a well-off Missouri farmer visiting Wichita on business died

after drinking carbolic acid in Flossie Jackson's resort at 217 Tremont. The groggy man mistook it for whiskey. Police declined to investigate, saying it was an accident. One of the farmer's sons complained that $100 and a set of gold cufflinks were missing from his father's effects. The *Beacon* also alleged that brothels along The Row were being allowed to sell liquor on Sunday while saloons around others part of the city could not. Mayor Ross admitted to performing an about-face on Tremont. "I tried to scatter these people once and I do not intend to do it again," he said. "They scattered all over town, one of them within two blocks of my home."

The first real change in Tremont Street's character came from a source other than city hall: the Santa Fe Railway, which in late 1908 bought six blocks on the east side of the street to use for a new freight depot, sheds and yards. Properties from William Street south to the Wichita and Western Railroad tracks were cleared, with houses in decent shape sold and moved elsewhere (leading to a brawl between movers and renters). Despite shrinking in size by half, The Row's raucous career wasn't close to over. Police raids found opium and a coke den at the Texas Hotel on Tremont. Two players in a craps game opened fire on each other, hitting a bystander instead. Tremont was as bad as ever and about to get worse.

In August 1909, Police Chief Frank Burt ordered the closing of brothels and gambling dens on West Douglas, where half a dozen were operating between Main Street and the Missouri Pacific depot. The move came in response to complaints from legitimate businesses in that area. To accommodate the working girls who would be displaced, "King" Clark was hurriedly consulted about the availability of rooms on Tremont.

That October, a fourteen-year-old girl was discovered in one of the Tremont Street houses; plans were made to send her to the state's reformatory for girls in Beloit. The *Eagle* called Tremont south of William "one of the most cantankerous spots ever permitted to exist in a civilized community," with nearly every building "a den of vice." In a particularly descriptive mood, the *Eagle* said women in Japanese kimonos could be seen from the street, flitting through rooms in the houses. Men young and old visited in "a seemingly never-ending swarm."

New Mayor Charles Davidson issued another edict, ordering the houses on Tremont closed. When taking office, he explained, his intent had been that those houses would be allowed to operate so long as they did so in an orderly fashion and didn't serve liquor. He contended that they had failed to follow these instructions. More than morality, the real impetus for

closing the bawdy houses was the new Union Station planned a block east of Tremont. Wichita could not have The Row making a first impression on arriving visitors. "Curtains were drawn along Tremont after the mayor's order. But laughter and music could be heard coming from inside the houses," the *Eagle* noted.

Whatever enforcement measures were taken, the street had backslid by spring 1910. That March, an assistant state attorney general visited Wichita. Assistant attorney generals were periodically deployed across the state in places where the law couldn't or wouldn't be enforced. The message to local authorities was clear. Police Chief Burt visited Tremont, causing "a perceptible lowering of curtains and cessation of noises." The next month, illegal liquor charges were brought against Flossie Jackson, Maggie Plymell and three other resort owners along Tremont as part of a city-wide crackdown.

But Burt soon lost his job thanks to a death along Tremont and the newspaper war between the *Eagle* and *Beacon*. Early one Sunday morning in June, a laborer named Frank Smith was found lying on Tremont just outside a resort owned by Maude Jackson, Flossie's sister. Smith died on the way to the hospital. The county physician ruled that Smith had died of alcohol poisoning. However, the *Eagle* concluded that Smith had been murdered, citing reports of a scuffle outside Jackson's brothel and what appeared to be cuts and bruises to the dead man's face.

James McPherson, one of several police chiefs who tried and failed to clean up Tremont Street. *Wichita Police Department.*

Burt and the rival *Beacon* claimed that the *Eagle* had been persuaded of the murder theory by a blind clairvoyant known locally as the "sightless psychic." Burt offered a $1,000 reward for proof that Smith had been murdered. There were no takers. Nevertheless, Mayor Davidson, bowing to pressure from the *Eagle*, requested and received the resignations of Burt, his chief of detectives and another officer. Davidson replaced Burt with James McPherson, head of the local post office.

McPherson soon visited Tremont with newspaper reporters in tow, deploring its

crowded, unsanitary living conditions. Anybody who couldn't prove he or she had a legitimate means of support was taken to the police station "for investigation." Several bare-bones bawdy houses were inspected; some had only one room fitted with furniture. According to McPherson, the street was more than a center of vice: "The majority of the crime which is committed in Wichita can be traced to this street."

McPherson didn't catch any working girls in the act, although he did advise Flossie Jackson to take down some salacious artwork in her establishment. The Wichita Ministerial Association congratulated McPherson on elevating the city's moral climate. A letter writer to the *Beacon* had a different take: "While there is so much being said about Tremont Street in Wichita, and so many hands being lifted in holy horror against the women who occupy those places, I would like to know how many have tried to lift those unfortunate women to a higher plane of living? Prosecutions only drive them farther in sin."

That winter, the *Beacon* mocked the police department for sending what the newspaper called its famous "blind crew" to Tremont for a look. The crew found nothing amiss. A *Beacon* representative visiting the next day saw many women sitting behind windows on The Row, cigarettes on their lips.

Maybe police had been deceived by a new Tremont Street trick: the resorts, according to the *Beacon*, were using secret closets to hide up to ten women at a time when notified of a pending raid, a technique they'd previously used with stashes of whiskey. Along with their secret closets, the resorts had a few more techniques for keeping ahead of the cops (on those rare occasions when police were interested in enforcing the law). In 1912, it was reported that the resorts had set up a kind of telephone chain in case of raids. As officers entered one place, a woman grabbed the phone and shouted, "The bulls are after us, kid! You'd better tell the girls to duck out, quick." A few years later, police discovered that a man employed by a madam named Maude Sargent was cutting figure eights with his car on Tremont at night, using the headlights to disclose any officers that might be stationed there. Then there was the good old-fashioned payoff. In 1913, a detective admitted taking twenty-five to fifty dollars from Tremont's resorts for "protection." He made no defense and was fired. Another officer was alleged to be the lover of Maude Jones, who ran a resort on Tremont with her sister, Irene.

And so the history of Tremont Street rolled on, with only slight variations, through most of a second decade: crackdowns—usually after an election or appointment of a new chief of police—followed by long months of neglect. Flossie Jackson finally left Tremont in 1914—the same year the city changed

the street's name to South St. Francis—trading her twenty-two-room place on The Row for the Callender tract, a parcel of sixty lots in south Wichita. She had remarried and went by the name Ethel Skripsy. Old colleagues such as Maggie Plymell and Maude Sargent continued to rack up arrests on the street. Sargent finally agreed to quit the business two years later, after she was fined $300 and sentenced to sixty days under a new, stiffer ordinance. She was said to be worth $40,000, with a home in the "exclusive College Hill district."

There had always been a few factories, warehouses and retail stores on Tremont. Gradually, more and more legitimate businesses replaced the resorts, until in May 1916 the *Beacon* could report there were "only three undesirable places left." The next year, the *Eagle* reported that Tremont was "gone forever" thanks to the arrests of numerous resort owners, followed by their agreements to quit the business. The paper sounded nostalgic about the passing, saying that time had "tinged Tremont Street with romance.... But even the good old days have to go. Tremont Street had to go."

THE BOY IN THE SAND

*Society was always ready to kill the fatted calf and welcome the prodigal son
back, but there was no welcome for the erring daughter.*
—attorney for Mary Mork during her 1901 murder trial

Getting pregnant out of wedlock was hazardous to all concerned in early Wichita. For the unwed mother, ostracism and economic hardship were almost a given. Denunciation of "fornication" didn't come solely from the community or pulpit. In an 1895 opinion, the Kansas Supreme Court stated, "No law, statutory or moral, sanctions intercourse between the sexes except within the bounds of lawful wedlock." To argue otherwise ignores "the moral sense of mankind" and "the recognized customs and usages of society." Abortions were illegal, although available, and sometimes fatal to the women who had them. In 1896, a young woman died after being found wandering on South Lawrence (now Broadway), seemingly out of her mind. She'd been given what a newspaper called "poison" to induce an abortion. The man responsible for an out-of-wedlock pregnancy, while undoubtedly faring better, wasn't completely off the hook. He could be sued in civil court for breach of promise or charged with the crime of bastardy. The final person at risk in these situations was the infant. In 1898, four people were charged with murdering a newborn Derby girl whose body was pulled out of the Arkansas River. The defendants included the mother's parents and brother. Other newspaper stories told of babies tossed down wells, fed poison or beaten to death in a fit of rage.

East bank of the Arkansas River at Lincoln Street, site of a grisly discovery in 1901. *Author's photo.*

Partly in response, the Rescue Home for "fallen women" was organized in 1894. Inspired by a similar home in Omaha, the Rescue Home opened at 1103 North St. Francis in a brick building just north of Via Christ Hospital St. Francis. Four years later, trustees moved it to the former Wichita Hospital property at 1021 Tremont. During an eighteen-month period ending in June 1901, sixty women were cared for at the Rescue Home, according to an article in the *Beacon*.

This charitable institution, boasting twenty-two private furnished rooms and a large yard, provided a place for unmarried women to give birth with medical care and privacy. The women also were given employment opportunities as a means of supporting their children or, if necessary, help placing their children with some person or institution willing to care for them.

There's no telling how many lives—women and children—were saved or changed through the efforts of the Rescue Home. But even the well-intentioned Rescue Home couldn't save them all.

Mary Mork showed up at the Rescue Home heavily pregnant in the spring of 1901. She was twenty-three and had grown up in St. Marks, a German American community near Colwich in northwest Sedgwick County. Mary's mother, Kate, brought her to the Rescue Home. Mrs. Mork was a Minnesota native whose family numbered among the early settlers of the St. Marks area. She married Nicholas Mork and gave birth to eleven children—six girls and five boys—all but one who survived. They ranged in age from Mary down to a boy, Nickey, who was born just four months earlier than Mary's baby.

Both women spoke German, although Mary was also fluent in English. Physically, both fit the stereotype of the stout German hausfrau. But otherwise they were very different from each other. Family and acquaintances described Mary as flighty, stubborn and not particularly bright. One recounted how she constantly changed the topic of conversation. Another said she hid herself in a barn when a visitor came to call. Nicholas Mork said his daughter sometimes ran around the house for no reason at all. Mrs. Mork never gave the impression of being out of control.

Mary Mork moved to Wichita in her early twenties. Her father said he didn't try to stop her from leaving, feeling that she could support herself. In Wichita, Mary met a young man named Fritz Kiser, who asked her to marry him. Mary accepted. But after consummating the relationship, Kiser changed his mind and called off the engagement.

For a time, Mary returned to her parents' home in St. Marks, behaving more erratically than ever. When her pregnancy could no longer be concealed, she moved back to Wichita. Whether she told anyone of her condition other than her mother isn't known, but it's certain she hid her pregnancy from her father.

One week after being admitted to the Rescue Home, Mary delivered a healthy baby boy with a head full of black hair. Mrs. Mork told the home's matron, Belle Stanton, that a home must be found for the child. Mary's father could never know. Stanton agreed to help if she could. Until something could be arranged, Mary and her son could remain at the Rescue Home.

Two weeks later, Mary's mother returned. The decision had been made to try to place Mary's child with the Catholic orphanage in Wichita. The trio of women—Mary, Mrs. Mork and Stanton—set off for the orphanage with the baby boy in tow. For some reason, the mission proved unsuccessful. As they made their way back, Stanton heard Mary and her mother talking in German but couldn't understand the conversation. That same afternoon, Mary and her mother left the Rescue Home with the infant again, saying they intended to try to find a home for the child. At this point, Mary and Mrs. Mork were both carrying a child—Mary her infant and Mrs. Mork her four-month-old boy.

Jim Cairns, one of two policemen who accompanied Mary Mork to the river. *Wichita Police Department.*

Their departure didn't set off any alarms with Stanton. But later that afternoon, Mary and her mother were spotted on Douglas Avenue by one of the Rescue Home's nurses. They had only one child—Mrs. Mork's young son—between them. Police were notified. After locating Mary and her mother on West Douglas Avenue, a police officer took them to police headquarters for questioning about the whereabouts of Mary's baby. By this time, Mrs. Mork had three more of her children, all under ten years of age, with her. It made for a chaotic scene at the police department, as Mrs. Mork repeatedly tried to leave with her crying,

screaming children, only to be restrained by officers. Speaking in broken English, Mrs. Mork made it clear that she felt the police had no right to detain her.

Meanwhile, Police Chief Frank Burt questioned Mary. Mary first claimed to have given her baby to her mother, then said she'd given it to a nun from St. Francis Hospital whom she'd met on the street. A telephone call quickly proved that the latter story was a lie. Mary next said that she'd given her baby to someone else but could not provide any details.

Mary Mork eventually agreed to take the police to her baby boy. She got in a buggy with detectives Harry Sutton and Jim Cairns, directing them south on Main and then west on Lincoln toward the Arkansas River. At Wichita Street, Mary took the reins herself and guided the buggy to the riverbank. She got out and walked toward the water's edge, stopping and kneeling near a pile of willows. The officers watched as she dug around in the sand with her hands and pulled out an old blanket. Then she reached in again and pulled out the body of her son.

The morning newspaper labeled Mary Mork "inhuman." At the riverbank, she was said to have held the child's body at arm's length before handing it to one of the officers. Another report accused her of tampering with evidence by trying to loosen a cotton handkerchief drawn tightly around the neck of the child. On the buggy ride to the river, she was supposed to have said she hoped the child was dead—raising the chilling possibility it had been alive when buried.

It soon became clear that Mary was full of human feelings, however twisted and influenced by others they might have been. At the jail, she tearfully broke down in front of her father. He'd arrived dumfounded and enraged. He had no idea his daughter had given birth; he thought she was ill. "Mary, Mary, what have you done?" he asked through the iron grating of her cell.

Calming down, he questioned her in German. She admitted the crime, named the man who'd gotten her pregnant and reportedly implicated her mother, who was then sharing her cell. By the end of the conversation, Nicholas was again enraged. "You got into this trouble, you'll have to get out of it," he said. "I won't do a thing for either of you."*

Mary also confessed to a reporter from the *Beacon*. "I don't know why I did it. I was crazy, I guess." Mary said her father "would have killed me" if he'd

* A police department employee who spoke German reported the conversation.

found out about her baby. She and her mother intended to give the child away when they left the Rescue Home the second time, she said. Her mother "had nothing to do with killing the child." Then she burst into tears again. Mrs. Mork, speaking in broken English, seconded her daughter's account, telling the newspaper that she and her daughter had been "down near the river, trying to give the child away" when Mary "left me and when she came back, she said she had given it away." As for her husband's threatened abandonment, Mrs. Mork sounded unconcerned. "I own the farm and all of the property near St. Marks, and if the old man won't help us, we can go along without him."

A married couple came forward to say they'd witnessed odd behavior by Mary and Mrs. Mork. The couple lived in south Wichita, near the Arkansas River just north of Lincoln Street. They'd seen two women— later identified as Mary and Mrs. Mork—walk fast on Lincoln Street toward the river. Mrs. Mork appeared to be carrying a baby, while Mary lugged some other object under her cape. The two woman stopped about one hundred yards from the river and exchanged bundles. Then Mary walked on toward the river, while Mrs. Mork came back and sat down on the couple's porch. Kate Mork made small talk. A quarter of an hour later, Mary returned from the river, without her bundle, and the two women walked back toward a streetcar that ran to downtown.

At the hearing of the coroner's jury two days later, the body of Mary's baby boy was laid out on a table for jury members and other officers of the court to see. The infant was clad in the little blue dress that he'd left the Rescue Home in, his face smeared with the white sand of the Arkansas River. Mary cried hysterically.

Mrs. Mork held her own four-month-old son during the proceeding, paying interest but betraying no emotion. Nicholas Mork, despite his declaration at the jail, sat behind his wife and daughter, looking worried and consulting frequently with an attorney.

Mary initially wanted to plead guilty and throw herself on the mercy of court. But she refused to testify about what had happened. The coroner's hearing ended in warrants for both defendants being sworn out on charges of premeditated murder, a capital offense. The coroner's jury gave the cause of death as strangulation and burial in sand and water.

At the women's preliminary hearing two weeks later, numerous friends from the St. Marks area showed up. Mrs. Mork once again held her young

son, whom she kept with her in jail until her release on bail more than a month later. The boy laughed and waved his arms during the proceeding. Occasionally, Mrs. Mork stood and swung him back and forth. At other times, when interested by the evidence, she looked over her attorney's shoulder. Mary alternated between crying and holding her head in her hands. The women's lawyers presented no evidence at the hearing, and the defendants were bound over for a trial scheduled for that fall.

Despite the community's revulsion over the murder, there were some who felt the blame should not fall solely on Mary. The *Beacon* reported that some unnamed persons in St. Marks believed Mary's mother, Kate, to be responsible. That scenario falls within the realm of possibility. Mrs. Mork does not seem to have been afraid of her husband (or anyone else). Is it possible that, being the mother of a young son herself, she didn't want competition from an illegitimate grandson back home in St. Marks? Or that she was the one who feared a scandal? In any case, Mrs. Mork's story that she believed her daughter had given the baby away to someone during a fifteen-minute stretch along the river fails the common sense test.

Meanwhile, a signed letter to the editor of the *Eagle* pointed out that Mary couldn't have gotten pregnant in the first place without the participation of Kiser, who'd then abandoned her. Why wasn't the scoundrel being punished? In fact, Kiser had been arrested on a charge of bastardy. After initially denying responsibility, he admitted that he had seduced Mary by promising marriage.

Mary's attorneys used the months leading up to her trial to build an insanity defense. Numerous witnesses testified about her strange, irresponsible or possibly insane behavior in St. Marks before the birth of the child. Among other witnesses called to show her mental unfitness was a businessman for whom she had worked for a few days. He said she'd once admitted going into town to drink beer. The prosecutor responded that Mork "was raised where they were in the habit of drinking beer" and that such a habit for a woman was "depraved" rather than insane. Another witness—a trusty at the jail who'd brought Mary meals—said the accused sometimes ran from him, thinking he was her father and saying, "Father will kill me." At night, the trusty added, Mork paced her cell saying, "Oh, he promised me."

Mary wore a calico dress and sunbonnet to the trial, pulling the latter down tightly as she walked in and out of court and avoiding eye contact with spectators. Mary's attorneys appealed to the all-male jurors' sympathies

as fathers. They argued that a mother who killed her own child was by definition insane. The prosecutor stressed the community's moral obligation to respond appropriately to such a heinous crime. Jurors deliberated several hours before returning with a guilty verdict of second-degree murder. She was sentenced to twenty years.

In 1903, after numerous delays in setting a trial date, charges against her mother were dropped. The prosecutor cited the defendant's poor health as the reason—interesting in light of her evident robust health in the not-so-distant past. Kate and Nicholas Mork reportedly moved to Kingman County, Kansas.

Mary received a gubernatorial pardon in 1904 after her attorneys gathered signatures from some two hundred supporters, mostly from the St. Marks area. She was said to have conducted herself as a model prisoner.

In their reporting on the case, both the *Eagle* and *Beacon* left no doubt that many people were unsure who really killed Mary's baby.

DOWN FOR THE COUNT

*P*rofessional sports as we think of them barely existed in early Wichita. But there was money to be made betting on horse races, boxing matches and other contests—and perhaps even more money to be collected by manipulating the outcomes.

Wrestling had become Wichita's most popular sport by the winter of 1908, helped in part by the city's "wrestling policeman," George Wichmann. The magnificently muscled lawman was apparently something of a stiff in the ring, but he and the sport caught the public's eye. Women as well as men paid $0.25 to $0.50 for tickets to attend matches held on Fridays at Wonderland, the amusement park located on Ackerman's Island in the Arkansas River. The bouts were decided by whoever got two out of three "falls"—that is, whichever wrestler threw his opponent to the mat twice first. A purse of $200 went to the winner, while much more money changed hands among spectators.

An Austrian-born wrestler, Charles Deviluk, proved such a sensation after two victories in Wichita that he and Wichmann opened a gym above the Brown & Mahan cigar store and billiards hall at 106 West Douglas Avenue, where they and anybody else interested in the sport could train. Deviluk hoped to bring regional opponents such as the "Terrible Turk" and "Greek Demon" to Wichita to fight. And if any local wrestlers showed extraordinary promise, Deviluk said, they could be sent to that summer's Olympic Games in London.

There's no indication that Deviluk and Wichmann were anything but honest wrestlers. But not everyone played by the same rules. Before one of Deviluk's victories at Wonderland that January, a man named M.A. "Mack" Connolly stood up and issued a challenge. Speaking on behalf of a well-known Iowa wrestler named Turner, Connolly dared the winner of that night's fight to a match with Turner. But that wasn't all. In private, Connolly offered Deviluk $1,000 to throw the match to the Iowa grappler. Deviluk refused and told his associates to keep away from the would-be fixer. But he kept the matter quiet, not wanting the city's wrestling fans to know that such unsavory characters were associated with the sport. The secrecy proved most unfortunate for an elderly Pratt farmer named Edward Stanbaugh, as Mack Connolly had more than one trick in his bag.

Farmer Stanbaugh arrived in wrestling-crazed Wichita in February, having made the seventy-eight-mile trip from Pratt to take care of some business. He'd been in town about a week when he met Connolly. Connolly complained to the farmer that he'd just lost $2,500 fighting a wrestler called "Doc Turner." But after taking Stanbaugh into his confidence, Connolly told the farmer he had a plan for getting his money back: He could arrange to fight Turner again and get Turner to agree to throw the match. All he needed was a "mark"—someone not in on the scam to bet on Turner.

At that point, the perfect dupe conveniently showed up. He introduced himself as M. Porter Strickland, a Kansas City capitalist out for sport and adventure in Wichita. Strickland declared that he would bet $2,500 or any other sum on Turner in a rematch against Connolly, apparently not thinking much of the latter's abilities.

Now all Connolly needed was money to make the bet. It didn't take much convincing for Stanbaugh to agree to provide it (and receive a portion of the ill-gotten gains in return, of course). Stanbaugh went back to Pratt that week, borrowed $2,500 against his property and returned to Wichita.

The next afternoon, Connolly and the farmer took a hack from the Manhattan Hotel to Riverside Park. A sandy, secluded spot on the Arkansas River bank had been chosen for the bout. Strickland, Doc Turner and a few other men arrived. ("Turner" was not the Iowa wrestler of that name but rather an imposter named H.L. Coleman.) Connolly and "Turner" stripped to their waists.

Connolly threw his opponent to win the first round. It had been agreed that Connolly's foe would win the second round to make the contest appear

legitimate. But something went horribly wrong when "Turner" threw Connolly. Connolly didn't get back up. He lay in the sand, groaning and calling for help. Strickland and another man examined Connolly and concluded that he'd burst an artery in his neck—at which point Connolly began to spurt blood out of his mouth.

Strickland grabbed the money and ran, declaring that he'd won the bet. The other men fled, warning that Connolly was likely to die soon and anybody caught in the vicinity would be charged with murder. Stanbaugh ran, too, although his age made it hard for him to keep up with the others.

Back at the hotel, the farmer agonized over his role in Mack Connolly's likely death and probably lamented the loss of his $2,500 as well. Then, leaving his room after a few hours, he bumped into Connolly, who was not only alive but, to all appearances, in the best of health. Stanbaugh realized he'd been conned. He was reluctant to make an issue of it, considering his own role in the affair. But he eventually decided that getting his money back was more important than his reputation and reported the matter to police.

The next morning, police arrested Strickland at the Manhattan Hotel. Strickland readily told police where they could find Mack Connolly. Police had no difficulty locating Connolly, "Turner" and Duke Bishop, the man who'd held the bets, all at the same address on West Douglas. They were taken to jail. Connolly and the others didn't deny that they'd swindled the farmer. Indeed, they joked about it. There was later speculation that Connolly had produced the crowning touch of the con—appearing to spit blood—by biting down on a capsule containing fake blood.

The only city ordinance they could be charged with—working a confidence game—was a misdemeanor. The foursome pleaded guilty, paid fines of $100 each and were released. There was no legal way to force them to return the money.

The prosecuting attorney told the farmer he could swear out felony charges against the men in district court, but Stanbaugh did not press the matter. He may not have enjoyed the publicity and ridicule that were coming his way. A newspaper in Pratt, picking up the story, noted that Stanbaugh was better known in that town for moonshine than for his farming prowess. It was also pointed out that, were Stanbaugh to accuse the four con men of fraud, they could accuse him of attempting the same thing.

Connolly and his wrestling partner grabbed their bags and quickly departed town. "You people got off easy in this city," Connolly boasted to

a reporter for the *Eagle* before boarding a train. "It is usual when I come around for the papers to get out an extra [edition] concerning me." The con men had gotten their cuts and the city had taken its share, and as a newspaper noted, Stanbaugh probably wouldn't be betting on any more wrestling matches.

KING OF THE YEGGMEN

Wichita barreled into its fifth decade with something of a split personality. On one hand, it was the commercial and cultural center of south-central Kansas, the progress-minded "Peerless Princess of the Plains." A new electric power plant belched smoke from the tallest smokestack in the state. Streetcars connected growing neighborhoods. A new cathedral and ten-story "skyscraper" soared upward. On the other, it was a place where certain criminals operated without interference from—and sometimes even in cahoots with—police.

That didn't apply only to the cozy, long-established relationship that police enjoyed with operators of illegal saloons, brothels and gambling dens. Rather, a number of bank robbers, safe blowers and other professional criminals had reached an arrangement with the city: so long as they did their dirty work elsewhere, they wouldn't be bothered in Wichita. In retrospect, it was actually a sweet deal for the city, maybe even in keeping with its efficient, entrepreneurial spirit. Except, of course, that it was illegal, immoral and certainly detrimental to surrounding communities.

This state of affairs was only a rumor until 1910. Late that summer, Wichitans opened their newspapers to learn that their police chief was under investigation along with a gangster and one of the city's best-known bankers over a scheme to resell stolen U.S. postal stamps. More sensational allegations followed—of bootlegging and a "hidden bedroom" in city hall, federal grand jury tampering and additional collusion between cops and crooks. It led many to wonder, in the words of the *Atchison Globe* newspaper, "What sort of town is Wichita?"

Scandals rocked city hall in the summer of 1910. *Author's photo.*

John Callahan could answer that question as well as anyone. The charismatic gang leader might have been the best-connected person in Wichita during his day. Certainly he was the most recognizable member of its underworld. Callahan was a big man for the times, standing over six feet tall and weighing more than two hundred pounds. He wore a black Stetson, neatly creased, and usually carried a half dozen ten-cent cigars in the pocket of a freshly laundered shirt. His easy smile, coolness under pressure and supposed adherence to the criminal code of honor were often noted.

Callahan first attracted attention in Wichita for robbing the Clearwater bank in 1898 as part of the "Shorty" Wayne Gang. He returned to Wichita after prison, telling Police Chief George Cubbon that he'd behave. When Cubbon arrested him

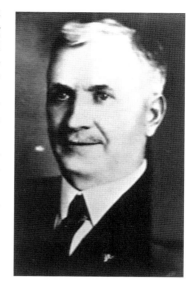

Police Chief George Cubbon.
Wichita Police Department.

for selling stolen silk to ladies on The Row six years later, Callahan claimed that he'd kept his promise since the silk had not been stolen in Wichita. Cubbon disagreed.

Chased out of town, Callahan used intermediaries to ask the next chief of police, O.C. Emery, if he could move back to care for his wife, Rose, who was suffering from consumption. Emery refused but did not interfere when Callahan came back for his wife's funeral. Later, Callahan sent Emery a letter in which he thanked the chief but said that he deserved thanks too. Acknowledging that his character was "not the best," Callahan said he nevertheless could "truthfully say that I have been a protection to your city" through his underworld connections. "Those men know I live here and that I am known to your most ablest officers, consequently if there is any safes robbed in Wichita, John gets blamed, and I am telling you the truth when I tell you that is the only reason your city has been left alone." Callahan invited Chief Emery to examine crime rates in other cities. "You will find the amount of 'professional' crime is very, very small in your town in comparison to other cities of the same size."

Not long after his wife's death, Callahan persuaded her twin sister, Daisy, to leave her husband and come live with him in "Callahan's Dump," which consisted of a three-room cottage and larger two-story frame house on Mosley Street, just north of the Morton-Simmons warehouse (now the Hotel Old Town). The property doesn't appear particularly unkempt in photographs, so its nickname may stem from its reputation as a place where thieves could "dump" or dispose of stolen goods.

The Dump served as Callahan's bootlegging headquarters and hangout for area "yeggmen," as robbers who used explosives were called. Callahan was known as the "King of the Yeggmen." On occasions where he didn't take part in a job himself, he often helped plan it and dispose of the loot afterward.

Things didn't always go as planned. In the winter of 1908, Callahan and two accomplices tried to rob the bank in tiny Milan, in Sumner County. Just as they blew open the safe, local residents opened fire on the trio, who escaped in a stolen buggy before fleeing on foot through fields. They were arrested the next day in Clearwater with revolvers, burglars' tools and nitroglycerin in their pockets. Convicted of robbery, Callahan was allowed to return to Wichita pending an appeal.

Like other bootleggers, Callahan occasionally was inconvenienced by a police raid. In the fall of 1909, the city's Police Court judge sentenced him to a $500 fine and six months in jail on a liquor charge. As was customary, Callahan was paroled on forfeiture of his $200 bond and a promise to quit the business.

Days after his next bootlegging bust, in April 1910, Daisy put a revolver to her chest and fatally shot herself at Callahan's Dump. She was (depending on the source) either remorseful for leaving her husband or despondent over the litany of legal problems and illnesses afflicting her family.

Callahan had known Police Chief Frank Burt, who took over from Emery, for years. Burt was a longtime Wichita resident, businessman and Republican Party stalwart serving his third stint as police chief. He was intimately familiar with the city's arrangement with bootleggers, brothels and gambling dens.

Burt started buying stolen U.S. postage stamps from Callahan in 1910, paying half their face value. Exactly who suggested the arrangement was never settled. Burt in turn sold the stolen stamps to Levi Naftzger, president of Fourth National Bank, at 75 percent of their face value, pocketing the profit. Federal lawmen had suspected for some time that a fence in Kansas

was disposing of stolen stamps and other loot. A string of nine unsolved post office robberies in the summer of 1910—in Kanopolis, Woodbine, Dorrance, Burdick, Timken, Frederick, Paradise, Hope and Ransom—lent urgency to finding that operation.

The feds figured that any city where the revenue from legitimate stamp sales was less than would be expected would be a good place to start looking. That place was Wichita. In Wichita, the federal agents questioned "Professor" Henry Samuels, a patent medicine manufacturer who was the biggest user of stamps in the city. Samuels told investigators he purchased stamps at a discount from Naftzger, president of Fourth National, unaware that they were stolen. The banker told investigators he bought them

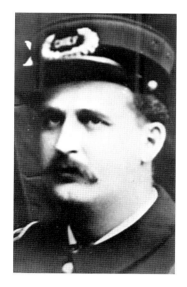

Police Chief Frank Burt. *Wichita Police Department.*

from Burt and also had no idea they were stolen. The police chief told investigators he got them from Callahan and knew they were stolen.

Chief Burt, who decided his best option was to cooperate with the investigation, announced plans to resign before news of the stamp case broke publicly on August 31, 1910. When it did, he made his resignation effective immediately. That allowed the *Eagle*, which had been calling for his departure over another matter, to claim credit for "breaking up a police system which has been a scandal in the eyes of the well informed." The connection between Burt and Callahan came as no surprise, according to the *Eagle*, which noted that the Dump had operated as "a notorious dispensary of beer and whiskey" with little interference. But "nothing could have been more shocking" than the banker Naftzger's alleged involvement, the newspaper added. Naftzger, for his part, issued a statement saying he'd been taken in by Burt, whom he knew as a longtime customer of Fourth National Bank. Naftzger said Burt claimed to have received the stamps as rewards for police work. "If there was any crookedness in the transaction, it was done by Mr. Burt," Nafzger said.

Of the three alleged conspirators, only Callahan was arrested, authorities not being worried that Burt or Naftzger would flee. Callahan, in custody, walked into the police station like he was thinking about buying the place. "I'll come through all right," he told a newspaperman

before making bail. "But did you ever hear of John Callahan getting scared and losing his head?"

Ten days later, he did just that. After making bail, and as a visiting photographer for the *Kansas City Star* newspaper tried to take photographs of the now famous Dump, Callahan turned loose his bulldog, Frankie, on him. The dog took a bite out of the photographer's thigh as two Wichita policemen stood by, doing nothing.

Mayor Charles Davidson, aware that the city's reputation was being shredded as badly as the photographer's leg, ordered the acting police chief, John Remspear, to apprehend Callahan. When Rempsear reported back that Callahan could not be found and that he knew of no illegal activity at the Dump, Davidson replaced him with a new police chief, James McPherson, who'd been head of the local post office.

McPherson, accompanied by the mayor's son, immediately raided the Dump, personally rolling six barrels of whiskey into a police wagon. He ordered the re-arrest of Callahan (who'd dropped out of sight temporarily) and evicted him from the Dump, offering to rent it to any law-abiding citizen who was interested. He ordered Frankie shot, if the dog could be found. "We intend absolutely to clean this city up," Mayor Davidson said. "I never realized what a condition existed, and above all what sort of men we have in our police department."

Police never did find Frankie; he became a sort of canine celebrity thanks to a lawsuit filed by the *Kansas City* photographer. John Callahan's lawyer said his client was generally a peaceable man and must have been in a bad mood when the attack occurred. His aversion to photography, however, was well known. Weeks earlier, a Callahan associate had smashed the camera—and punched the jaw—of a journalist from the *Beacon* who was trying to get a shot of the Dump.

The day after the raid on Callahan's Dump, the *Eagle* followed with screaming headlines of a new scandal: Mayor Davidson and Police Chief McPherson had discovered the remnants of a "secret chamber" or "hidden bedroom" in city hall, located near the police chief's office. Evidence suggested the room "has in times past been the scene of revelry and debauchery," the newspaper said. A large diagram of city hall, showing the location of the room, accompanied the article.

The new chief, McPherson, fired or accepted the resignations of former acting chief Rempsear and five other police officers—amounting to one-

fourth of the total police department—and instituted a system to ensure that liquor seized by police in the future would actually be destroyed.* The day after those revelations, a federal grand jury handed down indictments charging Callahan, Burt and Naftzger in a conspiracy. Within hours of Callahan's surrender and jailing on that charge, two office safes were broken into in the city—one across the street from the federal building in which he was indicted. "The renewal of safe-cracking in Wichita may be intended to indicate that the city was under very great obligations to Mr. Callahan," the *Eagle* speculated.

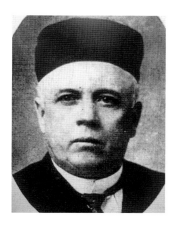

Levi Naftzger. *Wichita Public Library microfilm.*

Of the three alleged participants in the conspiracy, Naftzger had by far the most to lose. He had originally set up in Wichita as an attorney and lending agent. In addition to banking, he was an investor or principal in numerous undertakings, such as the laying of natural gas pipelines in the city. (Naftzger Park in downtown Wichita is named for a son of the banker.)

Naftzger had been connected with the bank since 1892. From a start with about $50,000 in deposits, it had grown to hold $2.5 million and was located in a handsome four-story brick building at Market and Douglas. Less than a week after news of the stamp case broke, Naftzger sold his stock in Fourth National to a group that included former mayor Ben McLean. Citing "the false accusation recently made against me, I have decided that it would be better that I, being only one, should suffer the loss," he wrote in a statement. The allegations against Naftzger did not affect the price he received for the stock, which was reported as $180,000.

Naftzger's wealth seemed to argue against his participation in a scheme that could not have brought him more than $1,000. As he said, "I would not put my head in a noose for the purpose of making a few pennies." Nevertheless, to be safe, he assembled what was viewed as the most impressive legal team

* A subsequent investigation by the city's civil service commission found no convincing proof that the "hidden room" had been used for sexual shenanigans but plenty of evidence that confiscated booze had been enjoyed or resold by police. Five years later, another police chief, O.K. Stewart, lost his job after admitting to appropriating seized liquor.

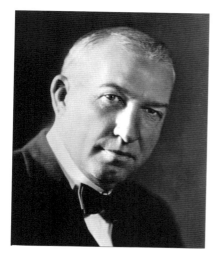

Sam Amidon, attorney for Levi Naftzger, called defending the banker his most difficult case. *Sedgwick County District Attorney.*

ever put together in Wichita, headed by Sam Amidon, who rushed back from a trip to Europe to help.

The men's trials got underway with a startling accusation the next spring. U.S. Attorney Harry J. Bone announced that former police chief Burt would plead guilty. That was not unexpected (though still worrisome to his codefendants). But Bone also announced plans to charge two members of the grand jury—part of the group that had indicted the trio—with trying to bribe fellow jurors to clear Naftzger. "There is a big pile of money in it for you and me if [an indictment] is not returned against Naftzger," one of the jurors allegedly told another. The other accused juror supposedly made a similar statement after visiting Sam Amidon's law office. Amidon, after hearing of Bone's allegation, immediately demanded that Judge John Pollock appoint a three-member commission to investigate; it exonerated Amidon the next day.

Callahan's trial took place first. As Burt began testifying, Callahan stared at him with "cold, gray and piercing eyes," one observer noted. But he sat back and chuckled when Burt denied ever having received a share in proceeds of the Dump. Burt testified that Callahan, despite his reputation for not cooperating with police, had agreed to snitch on his fellow yeggmen—Edward "Indiana Eddie" Earl and seven others—to avoid jail time. Callahan "told me he had never done a thing like it in his life, but he would turn the men over to me that robbed the Hope and Burdick [post] offices," Burt told jurors.

Callahan, in his testimony, readily admitted one crime. With a smile, he said he had paid Burt monthly for the privilege of selling whiskey out of the Dump. Callahan claimed that the first he heard of stolen stamps was when Burt came to him and asked for help after federal agents began their investigation. To help Burt get evidence for those agents, Callahan said, he had acquired and passed along stamps stolen in the robberies in Hope and Burdick. Callahan denied furnishing the names of the robbers to anyone. On cross-examination by U.S. Attorney Bone, Callahan flatly refused to

reveal where he had gotten the stolen stamps. Jurors convicted Callahan on two counts of receiving stolen stamps.

Naftzger, at his trial, maintained that he never suspected the stamps were stolen and never met Callahan. Naftzger's attorney, Amidon, tried to show that Burt entrapped his client because of an old grudge. The trial took a revealing turn during Naftzger's cross-examination, when the banker didn't deny telling someone he'd been "too greedy for money."

Observers agreed that the case against Naftzger came down to a question put to jurors by the prosecutor: "Is it reasonable to assume that a smart businessman would have bought all these stamps at a discount without some suspicion entering his mind that they were improperly obtained?" The jury, after deliberating thirteen hours and casting more than one hundred ballots, convicted Naftzger on one of the four counts—that of receiving stolen property. Naftzger got fifteen months in the federal penitentiary and a $5,000 fine; Burt the same amount of prison time and a $1,000 fine; and Callahan five years in prison and a $1,000 fine.

Neither Burt nor Naftzger ever served a day in prison. President William Taft pardoned Burt later that month, based on Bone's recommendation. The U.S. attorney had promised the former police chief he would not be imprisoned if he cooperated in the case. The next year, the U.S. Circuit Court of Appeals in St. Paul, Minnesota, reversed the conviction against Naftzger, accepting Amidon's argument that it never had been proven that the banker knew the stamps were stolen. Both men resumed their business careers. Naftzger later became president of Southwest State Bank, and Burt sold adding machines, among other things.

Callahan didn't fare as well, although he, too, was eventually pardoned— by President Woodrow Wilson—and released from Leavenworth in 1914. "I intend to be a good citizen," he told an *Eagle* reporter, who found him lounging in the northside home of a relative with Frankie the bulldog by his side. However, Sumner County authorities eventually succeeded in making Callahan serve a portion of the state prison sentence he'd been given years earlier for robbing the bank in Milan. That led the sympathetic *Eagle* to compare him to Jean Valjean, the famous hero of Victor Hugo's *Les Misérables*. "He is a real man who has real merits and who has made real mistakes," the newspaper noted.

Assigned to the prison coal mines, Callahan was paroled in 1917. The three-time ex-con opened a restaurant called the Little Traveler's Inn, located near the city's old No. 1 Fire Station on North Market. Interestingly, Callahan was paroled to the custody of Wichita's election commissioner,

raising the question of whether, in addition to crime, he had played some role in city politics. At least one out-of-state newspaper article referred to him as a "former political boss."

But Callahan seemingly found it impossible to stay out of trouble. He was arrested the next year for driving while under the influence, possessing liquor and stealing an automobile. The next spring, Callahan was shot and seriously wounded by a plainclothes deputy city marshal after he was found in an alley with a stolen car. Callahan joked with doctors working to save his life, refused to answer questions from police about his accomplices and upbraided the deputy marshal who'd shot him when he showed up in his hospital room. "Well, why don't you wear a uniform, so someone can tell you're an officer?" Callahan asked. "If I had I couldn't have got close enough to shoot you," the deputy replied.

In a philosophical 1920 interview with the *Beacon* not long after being shot, Callahan called himself "a man who has made a miserable failure of his own life." He continued to rack up arrests for bootlegging, including at least one charge under the federal Volstead Act. He also earned a second nickname, "Habeus Corpus John," for the voluminous legal motions he wrote trying to free himself from various lockups. One judge privately admitted that Callahan's legal efforts would have done credit to a lawyer.

In 1922, the former chief of Wichita's underworld was released from jail for the last time after agreeing to leave the state for at least a year. Still paralyzed in one leg from the shooting, he returned to Wichita and died in his sleep in 1936 at the age of seventy.

THE SALT AND SUGAR DOCTOR

Tennessee, Feb. 20, 1912
Prof. H. Samuels, Wichita, Kan.

Dear Sir: I am sending the treatment back that you sent my wife some time ago. She is dead now. The treatment you sent made her worse and I can prove it.[*]

Long before Wichita became the "Air Capital of the World," it enjoyed a more dubious distinction as a major producer of fake medical cures. In the winter of 1914, four physicians pleaded guilty to charges of sending fraudulent medical treatments through the mail. But those physicians' bogus healing aides paled in comparison to that of a fifth Wichitan indicted with them: "Professor" Henry Samuels, owner of the Samuels Remedy Company.

At his peak, Samuels employed a small army of clerks to handle thousands of orders arriving from across the United States. Samuels's remedy, which he claimed could cure virtually any malady, was a colorless liquid administered via eye drops. Samuels boasted that he'd spent years developing the secret formula for what was known as "Samuels' Systematic Remedy."

Samuels didn't operate out of some shadowy back room. On the contrary, he was one of Wichita's best-known figures, a prominent businessman with a formidable set of mutton chop sideburns whose comings and goings were chronicled in the city's newspapers. He gave parties, gave to charity and

[*] Letter on file with the American Medical Association, 1912.

once administered his "remedy" to a chimpanzee visiting the city as part of an entertainment troupe.

Pugnacious and flamboyant, he struck back at any person or organization who questioned the efficacy of his potion. If Samuels ever harbored such doubts himself, he never let on. He was either self-deluded to the point of megalomania or one of the most colossal frauds in the history of U.S. medicine. And unlike the physicians with whom he was indicted, he had no intention of pleading guilty.

Samuels, by his own account, started his career in Quincy, Illinois, in about 1870. He was soon traveling about the Midwest to practice his craft. By the mid-1880s, he was making annual trips to Wichita, seeing patients at temporary offices set up in the Occidental and Manhattan Hotels. At the time, Samuels primarily sold eyeglasses, although a newspaper advertisement noted that he also inserted artificial eyes. Samuels advertised heavily in the day's newspapers, evidently believing in the power of testimonials. The ads accompanying his early visits included endorsements from a half dozen Wichita physicians, several of whom said they wore Samuels's glasses, plus accounts of near miraculous restorations of sight through the glasses from Topeka and Lawrence.

In 1886, the *Beacon* reported that the "celebrated optician" was already a "household word" in the city. Two years later, he'd added a few prominent state officials to the list of clients in his ads. In 1901, what appears to be a paid item in the *Beacon* called Samuels the "greatest eye corrector in the United States," noting that he had published a book, *The Use and Abuse of the Eye,* and added two ex-governors as endorsers. A drawing of a handsome young Samuels adorned the ad.

Samuels invested in Wichita real estate when not hawking eyeglasses. Sometime before 1903, he moved his wife and daughter to Wichita, for that year he placed a somewhat peculiar help-wanted ad for a housekeeper in the *Eagle,* detailing his current housekeeper's dereliction of duties.

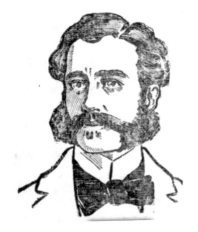

"Professor" Henry Samuels in an early advertisement. *Wichita Public Library microfilm.*

Samuels advanced from selling eyeglasses to marketing his cure-all remedy in 1904 with a breathtaking piece of hubris that appeared in a special "World's Fair Souvenir Edition" of the *Beacon* on May 30. "It remained for the closing years of the nineteenth century to produce a man equal to the task of solving the mystery of human illness and providing a cure for it," the piece reads. "That man is Prof. H. Samuels." Samuels, the article continued, discovered that he could treat "most, if not all" illnesses "through the medium of the eye." That naturally included eye troubles such as cataracts and blindness but also eczema, kidney trouble, deafness, heart trouble, consumption, morphine addiction, hay fever and "etc." Samuels's groundbreaking theory (not explained in this particular article but alluded to during later legal proceedings) was that nerves in the brain controlled body parts, so many problems with those parts must originate with the nerves. And the nerves could be reached through the eyeballs, apparently through mere proximity or osmosis.

Samuels started his "systematic" research some twenty years earlier, the article noted. He finally concluded that particular eye disorders were associated with certain illnesses of other parts of the body. Once he'd made that discovery, he found it "a comparatively easy matter" to come up with the cure—his "Systematic Remedy." Samuels had tested the remedy successfully on "hundreds" of patients, despite persecution from the established medical community in places he'd previously worked, including Topeka and Kansas City. A one-ounce bottle of the remedy sold for five dollars.

To put Samuels's success in context, it helps to remember that in 1910, the life expectancy for the average U.S. woman was fifty-one years; for a man, even shorter. People suffered and died from maladies like the flu that today we might not miss a day of work over, while minor aches and pains became lifelong afflictions. Anything that promised relief was worth a try, and the availability of newspapers as relatively new mass-market advertising made it easier to entice the desperate and gullible.

Samuels practiced his trade without interference in Wichita. In Indian Territory (the future Oklahoma) to the south, however, he was arrested in Ponca City, Alva, Newkirk and Pawhuska on charges of practicing medicine without a license. In response, Samuels fired off open letters to the newspapers complaining of harassment. He addressed one to a Ponca City physician he blamed for his trouble in that particular city. Samuels said he had learned that the physician had only recently graduated from medical school and so had "not as yet had time to help fill the graveyard."

He went on to name yet another physician in that city and described in detail how he had cured him of constipation and "creeping paralysis."

In Wichita, Samuels listed himself as "the modern healer" in the *Eagle*'s classified ads. Samuels and his family moved into one of Wichita's finest residences, located at 723 North Lawrence (now Broadway, site of an AutoZone). Flush with cash, he bought a two-story brick office building at 238 Main and a three-story brick building at Third and Santa Fe. The Farmers and Bankers Life Insurance Company listed him as an original stockholder. His biggest purchase was the old Topeka Avenue hotel, which he said he needed to accommodate his "large office force." Plans called for the bottom floor to be turned into a vaudeville theater called the Empress. His wife, Rebecca, hosted members of the tony Entre Nous ladies club at the couple's home on Lawrence. Samuels gave her a new car for Christmas.

In 1910, Samuels unwittingly helped start the chain of events that led to the arrests of Police Chief Frank Burt, bank president Levi Naftzger and underworld boss John Callahan for selling stolen U.S. postal stamps. Samuels told investigators about buying large quantities of stamps from Naftzger at a discounted rate.

Samuels, when not running his remedy company, was a sort of querulous busybody who had the ear of the newspapers because of his advertising budget. He complained at various times about plumbing requirements for his new headquarters, vandalism of his rental properties, a traffic ticket he'd been given by police and the large number of crows infesting the city.

Samuels's fame spread wide, though not necessarily in flattering ways. In 1910, he was the subject of a scathing article in the *Journal of the American Medical Association* titled "'Professor' Samuels and His Eye Water." The *Journal* called him "one of the latest comets to flash across the firmament of quackery." Two specimens of Samuels's potion had been sent to the AMA, which had tested them in its laboratory. What was actually in the stuff? An analysis found the cloudy, slightly salty-tasting solution to contain about equal parts of sugar and salt dissolved in water, with a trace of sulfate that probably came from Wichita's public water supply. The *Journal* said that Samuels's targeting of suffers of chronic ailments not curable by legitimate medicine made an underhanded kind of sense—such people were susceptible to promises of miracle cures, the more outlandish the better.

Samuels, according to the *Beacon*, took the AMA's attacks in good humor, saying they showed how much his competition for patients worried the

medical establishment. Perhaps prompted by the outside attention, Kansas's state board of health charged Samuels with selling misbranded medicine in 1911. But Samuels was already planning to relocate to Detroit, either to escape the state's newfound interest in regulating him or to expand his business in a bigger city (both stories made their way into print). He sold the family's piano and other household goods and made gift of land at Tenth and Washington to the humane society, "one of his last public acts in Wichita" before leaving, according to the *Beacon*.

Samuels moved to Detroit with what he claimed was a hearty welcome from the city's Board of Commerce, but he soon discovered that not everyone was happy to see him. Samuels was told by representatives of the city and state government that he must register as a doctor if he intended to practice medicine there. Samuels replied that he did not call himself a doctor. Told that his using the title "Professor" in the context of healing ailments implied the same thing, Samuels responded that he had been known by that title for forty years and, furthermore, that there was no organization capable of certifying or licensing him because he had invented the system he used. "Columbus had no license to discover America," Samuels was quoted as saying. "Who could license me to practice a system of my discovery?"

In late May, police raided Samuels's offices in downtown Detroit. Informed that the remedy was kept behind a locked door, the officers threatened to break down the door before an employee identified as Samuels's nephew let them in. Samuels himself was accosted by two government representatives as he stepped out of his car in front of the Hotel Pontchartrain, where he and his family were staying. He was thrown into jail, where he said the prosecutor paced in front of his cell and asked him "if that is like your luxurious quarters at the hotel." His wife didn't discover his whereabouts until she read about his arrest in that evening's newspaper. He was charged with practicing medicine without a license.

Details of Samuels's operation surfaced during a preliminary hearing the next month. Samuels had run full-page ads in the New York and St. Louis papers to lure customers. He also bought mailing lists of prospective customers and mailed them copies of the newspaper ads and a list of forty-six diseases that his remedy could cure. Recipients were asked to place a cross in front of whichever illness they wanted to be treated for. Regardless of where the cross was placed, the company's office manager testified, "Samuels sends out the same medicine for all diseases."

The Detroit newspapers proved less kind to Samuels than their counterparts in Wichita. One mocked him as the "salt and sugar doctor." Samuels showed

up in court in Detroit dapperly dressed in a gray suit, with blue socks and whitewashed tie. He was said to enjoy the sparring between his attorneys and an assistant prosecutor. The case was dismissed after the office manager and another witness disappeared. But Samuels said the seizure of his patient list and correspondence made continuing business there impossible. He announced that he would return to Wichita. He had no intention of quitting the business, telling a reporter, "I told them in Detroit that they could not beat me because I had the Wichita pluck."

Samuels and his family were welcomed back into Wichita's business and social bosom. In August 1912, the *Eagle* reported that Samuels had installed a "mailometer" in his office capable of stamping and sealing five thousand envelopes per hour. That same month, he announced plans to build a new three-story building at English and Main Streets at a cost of $35,000, having outgrown his space in the Samuels building on south Topeka. Samuels announced several charitable ventures. He started a night school where recent immigrants could learn English and paid the salary of its teacher. He set up a $1,000 prize for a new sporting contest known as "auto polo."

The *American Medical Association Journal* wasn't quite done with Samuels. In a book called *Nostrums and Quackery*, the AMA reprinted its earlier article on Samuels and added, "If Wichita has the right kind of public prosecutor, that city can be made to be just as unhealthy for Samuels as [the prosecuting attorney] made Detroit. But the case would need to be handled without gloves."

A publication of the Wichita Business Association addressed Samuels's return. "Only recently the king of quacks and 'fakers,' run out of a big Eastern city, mercilessly handled without gloves by the American Medical Association, has returned to Wichita. Some people received him actually with open arms," that publication read. "Some seem to think that the boost that postal receipts get from this mail-order business atones for any shortcomings he possesses."

In the summer of 1912, Samuels staged a favorite marketing stunt of the era, taking out full-page newspaper ads that offered $2,000 to anyone who could prove that the testimonials in his ads were not genuine. He had already deposited the money in the American State Bank of Wichita, he said (a letter from the bank's president was displayed). The testimonials purported to come from Alabama to California, although the writers were no longer physicians—just regular, thankful folks. In addition to curing the

diseases mentioned above, the remedy was now known to work on bladder and stomach trouble, rheumatism, appendicitis, neuralgia, tuberculosis, lung trouble and bronchitis, nervousness, Bright's disease (chronic inflammation of the kidneys), impotence and more. A photograph of Samuels showed him to have aged some since the earlier drawings, but he was still looking prosperous in his pinned necktie and extravagant sideburns.

Samuels was still apparently selling plenty of his remedy. In May 1913, he announced plans to build a six- or seven-story hotel at Topeka and William Streets with a Topeka partner, at a cost estimated at $200,000. It never happened, as Samuels's luck was about to take a turn. That summer, he was sued by an eighty-year-old woman who claimed he'd promised to cure cataracts on her eyes for $100. A jury awarded her $800. In September, while vacationing in Atlantic City, Samuels was bitten by a sea creature and treated for possible blood poisoning. Days later, he and the four mail fraud physicians were indicted by a federal grand jury in Wichita.

From the start, Samuels's case seems to have been treated differently. Accused of seven counts of misusing the mail, his bond was set at $10,000. Dr. Raymond Clapp and Dr. James Dorsey, each accused of six counts of misusing the mail, had their bonds set at $1,500 and $1,000, respectively. The indictments were apparently part of a campaign against fake medicine by the secretary of the State Board of Health. Clapp and two other indicted physicians entered pleas of nolo contendere. Despite receiving a scolding, they were fined only $100 each. The fourth physician, Dr. J.K. Dorsey, was fined $250.

Samuels told friends that he was closing his business for good. The reason became clear when the postmaster general of the United States issued a fraud order against Samuels, meaning he could no longer receive mail and money orders. The local post office was soon stopping and sending back hundreds of letters a day addressed to the remedy company. Samuels gave away 150,000 envelopes to the Rescue Home for unwed mothers.

Samuels's trial opened with U.S. Attorney Fred Robertson ridiculing the defendant sufficiently to produce laughter in the courtroom. Government investigators, the prosecutor explained, had sent twenty "decoy letters" to the Samuels company from fake patients to see how it would respond. In response, the company sent letters indicating that its potion "would cure

consumption, syphilis, make fat men thin, thin men fat, mend sprained ankles and had other ridiculous powers," the prosecutor told jurors. Samuels's defense was that he himself had never promised to cure specific ailments, but rather just forwarded testimonials from satisfied customers.

The scope of Samuels's business was testified to by Frank Gray, owner of a Kansas City adverting agency, who said he'd written and placed advertisements for forty publications across the country with a total circulation in the millions. Samuels had paid the agency about $175,000 for the work—or about $4.5 million in today's money—90 percent of which went to the newspapers.

One of the government's decoy letter writers testified that he'd written to Samuels with the story that one of his legs was two inches shorter than the other. The company quickly responded with written testimonials praising the Samuels remedy. When the decoy writer did not respond in kind, the Samuels company sent additional letters and materials, eventually offering to drop the price of a bottle of the cure to three dollars. In other testimony, physicians said that Samuels's remedy could have no possible effect on any body part other than the eyes—although one doctor said a person could hypothetically be cured by "suggestion" when buying and using the product. A seventy-one-year-old blind man testified that he'd bought twenty-five dollars of the remedy but had not regained his sight. "I asked him if he could cure me and he said he was curing people every day like me and he didn't see why he couldn't cure me," the witness said.

When the defense's turn came, Samuels's attorneys—including the ubiquitous Sam Amidon—presented nineteen witnesses who said the remedy had cured them or their loved ones of everything from catarrh (a buildup of mucus in the nose or throat) to an inflamed eye, severe headaches, asthma, lung trouble, lumbago and appendicitis. Twenty more patients were waiting to testify on the defendant's behalf when Judge John Pollock said he'd heard enough, reiterating his earlier ruling that the crux of the case was whether Samuels—not his patients—actually believed the remedy was effective.

Samuels, who'd been so quick to answer any skeptics previously, did not testify.

Jurors deliberated ten hours and cast thirty ballots before convicting Samuels on all eleven counts. He showed little reaction to the verdict other than whispering to his attorneys as the verdict on each count was announced. He

quickly left the courtroom and was met outside by several defense witnesses, who told him how badly they felt about the outcome.

Samuels faced a maximum sentence of five years in prison and a $1,000 per count. The prosecutor, Robertson, urged a significant sentence, saying the case was being watched far beyond Wichita and would send a signal about the consequences of peddling fake cures. Judge Pollock sentenced Samuels to one year and a day and fined him $5,500. "It is a most singular case," the judge said from the bench. Samuels's customers "were benefited, but through their credulity. They were benefited because they did not believe it possible that they could take something so highly recommended and not get well.... The people derived a benefit, but not from the medicine and the defendant is too intelligent of mind to believe that the medicine had in it and of itself a curative popery."

As a final indignity, after giving himself up to begin his sentence, Samuels was served with court papers by the *Eagle*. As one of the many newspapers where he'd spent so much money over the years on advertisements, it sued him for $242 in unpaid bills for printing labels for his remedy bottles.

Samuels, sixty-seven and frail at the time he left Wichita by train for prison, served his full sentence despite the efforts of friends to secure a second trial or a pardon. At Leavenworth, Samuels may have come closer to actually practicing medicine than ever before. He was an assistant in the hospital ward of the prison, wearing a hospital uniform instead of regulation prison clothes.

THE NIGHTINGALE

Her brow is like the snow-drift,
Her neck is like the swan,
Her face it is the fairest,
That 'er the sun shone on.
That 'er the sun shone on.
And dark blue is her eye
And for bonnie Annie Laurie
I'd lay me down and die.

On a December day in 1914, those lucky enough to be within earshot of Wichita's city jail heard the old Scottish ballad "Annie Laurie" sung as they never would again. The Nightingale, as Alice Irwin was known, was giving her last performance. Alice possessed a soprano voice as sweet as the winged nocturnal songstress. In an earlier life, she had performed for society events and theater audiences in Wichita. But she earned her nickname singing as an inmate in the city jail—a kind of caged bird herself.

On that day in December, Alice put her voice to use one last time. "It's getting near Christmas, and I'd like to be out," she told her jailers. The turnkey and desk sergeant considered her request; they weren't without the Christmas spirit, after all, and Alice was a threat to no one but herself. Before agreeing, her keepers added one stipulation. The sergeant drew up a sobriety pledge, good for five years. Alice signed it. "Now sing 'Annie Laurie'

and be on your way," the turnkey said. Alice sang. All over the City Building, clerks, commissioners and her fellow inmates stopped what they were doing and listened. As they did, more than one must have thought to themselves of the tragic flight of the Nightingale.

Alice had charmed Wichitans with her voice since her arrival some two decades earlier. Reputed to be the daughter of a wealthy Philadelphia physician and educated at a leading eastern college, Alice married a businessman named George Billadeau and headed west with him. The couple moved in "good society," according to the *Beacon*, residing in spacious apartments in the then-new Thompson Building at Market and English Streets. One report was that Alice was of French descent, related to people of substantial property in Quebec.

In 1893, she took part in an amateur entertainment given at the German Evangelical Church on south Emporia. While all the performers were lauded, Alice stole the show, receiving "immense applause" for several songs sung in an "elegant manner," according to the *Beacon*. "She was encored and the audience insisted on a repetition of the numbers." In 1895, she sang a spiritual, "Because of Thee," for the largest convention gathered in Kansas up to that time. She and her husband both sang some "choice songs" at a party that year for employees of the Wichita trunk factory, where George worked.

George's sudden death a few years later struck Alice hard. A saloonkeeper named Harry Rogers, who'd been her husband's friend, offered sympathy. She quickly married him. The couple lived over a saloon he owned on East Douglas. In 1898, it was reported that Rogers had disappeared. Robbery or murder was at first suspected, but it was soon discovered that Rogers had left a note with his barkeeper, saying he was leaving the city and it would be a cold day somewhere before he returned. Rogers was behind in payments to his suppliers. The *Beacon* described Alice as heartbroken over her husband's departure.

What wasn't revealed until years later was that Rogers had run off with $2,000 in insurance money Alice had received from her first husband's death. To support herself, Alice turned to music full-time, giving piano and voice lessons at 125 South Lawrence (now Broadway) Avenue. Tough times cut into the number of people able to hire musicians for entertainment, and some who could shunned Alice after her second marriage to a saloon owner.

Alice found work playing piano in a saloon. She was popular, adept at the rollicking tunes that filled the place with male patrons. She also discovered a fondness for liquor, illegal under Kansas's prohibition law but widely available in the state's biggest city. Under its influence one night, she launched into "Home, Sweet Home." It was a popular sentimental tune from the era with the repeated refrain, "There's no place like home." Alice's performance caused men to quit drinking and file out of the saloon when she'd finished. Incensed, the proprietor fired Alice on the spot.

Alice's next job was on Wichita's notorious Tremont Street, playing piano in a bawdy house owned by Inez Miller, one of the city's best-known madams. It was the only position Alice could find, and she was determined to keep it, playing all night long when necessary. She lived with a bartender named Harry Irwin at 516 William Street, just around the corner from The Row. She was now known as Alice Irwin, although it's unclear whether the couple officially tied the knot.

One night, Alice again played a sad song that put a damper on things on Tremont Street. "You're drunk," the manager said, and he fired her. Amazingly enough, it was at least the third time her ability to sober up a crowd in Wichita had been demonstrated in such dramatic fashion. A former police detective recalled to the *Beacon* how Alice, when playing for a raucous dance at a fancy Murdock Avenue home, suddenly shifted gears. "She was a wonder at the ivories," the policeman said. "I was just about ready to call 'em down and put the 'quiet' on the house for the night when Alice Irwin stopped playing....'Here, all you folks listen and I'll play you a real piece,' she said. She began on that 'Home, Sweet Home.' I don't remember ever hearing anyone play it as she did....'Sing it,' somebody said. She did, and believe me she could sing. It broke up the gang. It took the devil out of 'em. When she got through they were through with the dance."

Alice fought a battle with the bottle and often lost. But the Nightingale's flight wasn't a straight descent. For a time, she played piano at a restaurant at 119 South Lawrence owned by Mrs. Minnie Smith. That job ended when the place changed hands, but Mrs. Smith remained a devoted and supportive friend during Alice's struggle with alcoholism.

In the spring of 1909, Alice was part of a production of *The Idler*, staged at the new Crawford Theater by the Wichita Stock Company. It's not clear whether she worked as an accompanist or played an onstage role, but Alice got second billing to the star, Mr. Louis Dean. An ad touted the show as "the

Alice Billadeau, the Nightingale, lies next to her first husband in Highland Cemetery. *Photo by Carrie Rengers.*

most finished performance ever seen in Wichita. A dramatic gem, gorgeously staged and elaborately costumed." In November 1914, police responded to a report of a woman lying unconscious in an alley along North Water Street. When an officer arrived, the woman was gone, but a handbag and notebook containing the name of Alice Irwin had been left behind.

It was probably that incident or something like it that landed Alice in the city jail the next month. Behind bars, the Nightingale usually sang uninterrupted from her own repertoire. At other times, a fellow inmate would ask for a favorite song. The *Beacon* calculated that hundreds of prisoners through the years owed Alice thanks for relieving their misery and monotony with her voice. Alice, after signing the sobriety pledge and being released in December 1914, returned to the jail with an armful of books as gifts for the inmates she'd left behind. According to friends, the December stay was Alice's last lapse and residency in the city jail.

Alice Irwin took ill in the summer of 1916. Alice had once told Mrs. Smith that she could not die happy unless her friend was at her bedside. That's what happened. Mrs. Smith first sent her physician to care for Alice in the Tourist Rooming House and then provided for her friend's treatment and a private nurse at the Wichita Hospital.

Mrs. Smith arranged a chapel funeral for Alice and burial beside her first husband, George Billadeau, in Highland Cemetery. The Nightingale was fifty-four. There's no record of the service, but another verse of "Annie Laurie" wouldn't have been out of place:

> *Like dew on daisies lying,*
> *Is the fall of her fairy feet,*
> *And like winds, in summer sighing,*
> *Her voice is low and sweet.*
> *Her voice is low and sweet…*

THE MAJORS GANG

Times were good. Money was plentiful. Banks were unguarded.
—*the* Beacon, *May 15, 1920*

The summer of 1919 turned into open season on banks in Kansas. And the Majors Gang of Wichita did much of the hunting. Operating out of a base in south Wichita, Walter Majors, his younger brother Ray and their cronies held up a series of banks while meeting little resistance.

On the morning of July 7, for instance, four well-dressed members of the gang walked into the Overland State Park Bank and ordered the people inside to put up their hands. They left with $3,700 in cash and Liberty Bonds (sold to finance the U.S. effort in World War I). Outside, meanwhile, their driver found a customer's new Buick parked with the engine running. He quickly claimed it as the gang's new getaway car.

An August 11 robbery of the Benton State Bank in Butler County proved more lucrative. That morning, four members of the gang—again, sharply dressed—entered the bank. "You are being held up, so hold up your hands," one of them told the cashier. The cashier made a dash for the back room but was stopped by another gang member. The bandits locked employees and customers in the bank vault and escaped with about $62,000 in cash and bonds.

About the only difficulty they encountered came in tiny Bartlett, in far southeastern Kansas. The gang had set out that morning with no particular

destination in mind, their regular wheelman, Major Poffenberger, driving a big Packard touring car. (Major was his given name, not a rank; he usually was called by his nickname, "Fat.") After breakfast in Fort Scott, the gang happened upon what looked like an easy target in the Bartlett bank. Just after Poffenberger let the Majors brothers and two other gang members out of the Packard in front of the bank, its chief cashier pulled up. "Good morning," the bank official and the getaway driver said to each other. The cashier got out and proceeded to talk with an acquaintance on the sidewalk, unaware a robbery was going on a few yards away.

Meanwhile, another Bartlett resident saw the four men enter the bank, became suspicious and commenced telling everyone she met on the street that a robbery was in progress. Just to be sure, the plucky Mrs. N.C. Vandermark went to the door and asked if a certain employee was in. One of the robbers guarding the door replied in the affirmative and invited her in, but Mrs. Vandermark said she'd come back later. Retreating to a hardware store next door, she finally got the attention of the bank cashier. The cashier loaded a shotgun inside the store and stepped outside.

Poffenberger had been watching the entire episode unfold as the other gang members emerged from the bank with about $20,000 in cash and bonds. As they drove away, the gang pointed two six-shooters and a Winchester rifle at the cashier. Neither side fired.

And so it went that summer. It's not known exactly how many banks the Majors Gang hit. The Kansas Bankers Association positively attributed five robberies to them and suspected them of more. Contemporary newspaper reports, presumably based on law enforcement sources, put the gang's tally at thirty or more, including some in Colorado, Texas, Missouri, Arkansas and Oklahoma, with a total take ranging from $300,000 to more than $1 million—or nearly $15 million in today's money. During the summer of 1919 alone, at least sixteen Kansas banks were held up or burglarized. Lawmen considered the Majors Gang "one of the most daring, efficient and fearless since the days of the Jesse James boys in Missouri," according to the *Beacon*.

The gang spared Wichita banks. Walter Majors and his gang, like John Callahan before them, seemed to count on the city's police to not be overly inquisitive so long as their crimes were committed elsewhere.

The gang presented a study in contrasts. Walter Majors and his brother Ray were "thin, sour and hard," in the words of a Topeka newspaper, although they did favor nice clothes and women for whom criminal behavior

wasn't a deal breaker. Walter stood five feet, seven inches tall and weighed 125 pounds; his younger brother was slightly taller and weighed no more. Both were sallow-faced, with light chestnut hair. The Majors brothers had grown up near the drainage canal in south Wichita; the family also lived for a time on a farm outside Newton, to the north of the city. It was said that Walter had served a criminal apprenticeship in the Jones-Lewis Gang— noted bank robbers who passed through Wichita—and also matriculated in a juvenile reformatory in Iowa. A third Majors brother, William, was killed while stealing a car in Tulsa. A fourth, Dudley, was jailed in Detroit for stealing an automobile. The youngest Major, Jimmy, was later accused of robbing a bank in Arizona.

The other two brothers in the gang—Major and Minor Poffenberger— were a "fat and weak" set of twins from Topeka, reportedly related to the Majorses through marriage and so close in appearance to one another that police (and newspapers) had difficulty telling them apart. Major Poffenberger had driven a taxi in Topeka and been busted for minor offenses such as possession of stolen property and of beer; he squealed on the seller of the latter after three days in jail—perhaps an indication of trouble to come for the gang. Other members included Charlie Morris, George Brown and another man of many aliases who would become infamous a few years later as Eddie Adams.

The gang didn't resort to violence during bank robberies, but it would be a mistake to suggest they weren't capable of it. Charlie Morris, for instance, repeatedly threatened his teenage bride with violence. He'd met the girl in Tulsa when she was fourteen, filled her head with promises of a glamorous life and brought her to Wichita to marry. She watched the gang plan heists at the hideaway on East Lincoln, divide up the money afterward and sometimes scatter in the middle of the night to avoid police. Morris once told the girl's mother that he might have to bump off her daughter. "She's too talkative," he said. She kept quiet, for the time being. But the gang's murderous behavior would soon be on display for all to see.

The prolific emptying of bank vaults alarmed the Kansas Bankers Association, which offered rewards and employed private detectives to find whoever was responsible. The U.S. Secret Service joined the hunt. So did lawmen in every town where a bank had been robbed, as well as others who were just after thousands of dollars in bounty money. As September 1919 arrived, the Majors Gang wasn't yet connected publicly with the

robberies. But they were high on the list of suspects. Wichita police chief S.W. Zickefoose was convinced that they were to blame following the Benton robbery.

That month, the gang's core—the Majors brothers and Adams—committed their last bank job together. On September 4, they held up the Baileyville State Bank in northern Kansas and then enjoyed themselves at a fair just down the road in Seneca before crashing their car and fleeing into a cornfield after police spotted them. Swiping another vehicle, they headed to Kansas City and decided to stage a different type of heist, targeting a downtown gambling den. Whether or not they were drunk—as one report suggested—the move was far riskier than robbing a country bank. The den had been owned by Harry Truesdell, a well-known figure of the Kansas underworld until his death a few weeks earlier.

In the early morning hours of September 5, the Majors brothers entered the establishment, which was located on the third floor of a building at 1209 Grand Avenue. One of the men inside drew his revolver on the Majors brothers before they could try anything, but Adams snuck in by another door and started a gunfight that killed a gambler named Frank Gardner. When the shooting was over, Adams, though wounded in the arm, helped rob the rest of the players before the trio escaped. A house detective from a nearby hotel heard the firefight and quickly informed the Kansas City vice squad.

Driving to Thirteenth and Oak Streets, the officers spotted a Buick parked at the curb with Eddie Adams standing beside it. Questioned by the police, Adams said he was the owner of the car and a resident of Atchison. When the officers asked to see the contents of several suitcases inside the car, Adams said they were locked and he'd have to retrieve the keys from a house at 314 East Thirteenth Street. As two of the officers followed Adams around a corner of the house, they were confronted by a man standing at the back door. "Put up your hands or I'll blow you off," the man said, not waiting for an answer before opening fire. One of the officers returned fire with a shotgun. The third officer, watching from the cars, saw one bandit and both of his colleagues go down in the fusillade. He exchanged fire with the gunmen before helping his wounded comrades to safety.

As neighbors gathered and more police arrived, officers went in the house and found Adams lying on the floor, hurt too badly to resist arrest. Ray Majors was found lying in some weeds outside the house. Walter Majors was wounded but escaped. The two policemen were seriously injured but recovered.

A search of the suitcases revealed Liberty Bonds totaling more than $28,000, some of them in envelopes indicating that they'd been taken in the Baileyville robbery. There also was a vial of liquid believed to be nitroglycerin, three Winchester repeating rifles, a Remington pump gun, a .38-caliber revolver, holsters, nearly two thousand rounds of ammunition and a first-aid kit.

The loot from the Majors Gang robberies had caused one big complication. Much of what they stole was in the form of Liberty Bonds, which couldn't be spent like regular cash. Instead, the bonds had to be "fenced"—sold by intermediaries for less than face value to people who didn't know, or didn't want to know, where they came from. The identification of one of those intermediaries created a sensation in Wichita.

Ten days after the shootout in Kansas City, Wichita police announced that a well-known member of the community, Dr. H.W. Queen, had been arrested in Memphis, Tennessee, based on accusations that he was the fence for the Majors Gang, if not the mastermind behind their entire robbery spree. Queen purportedly had $100,000 in bonds on him at the time of his arrest. His son, Emerson, and another Wichitan, Charles "Noisy" Blevins, were also taken into custody.

"Doc" Queen was a colorful and controversial figure in Wichita. A large, imposing man with a personality to match, he had come to Wichita about six years earlier from Alva, Oklahoma, where he'd been president of the local medical society, active in politics and an investor in various businesses. In Wichita, he opened a drugstore in addition to treating patients and seemed primed to assume a similar role in civic affairs.

In 1917, however, he was arrested for selling booze to Native Americans in violation of the state's prohibition law. He beat the rap by throwing blame on a one-armed African American porter at his drugstore. Divorced and remarried, Dr. Queen moved around Wichita quite a bit, living on South Lawrence (now Broadway), South Topeka, the Royce Hotel on North Water and at 1403 North Ash Street.

His landlady on Ash Street told a newspaper reporter that Dr. Queen could not have been involved in something like bank robbery. She said he saw patients at his residence; police believed the "patients" were actually fellow gang members. His son, Emerson, was known to be a narcotics addict and dealer, having served a stint in the Sedgwick County Jail. He'd been living in Little Rock, Arkansas, under an assumed name.

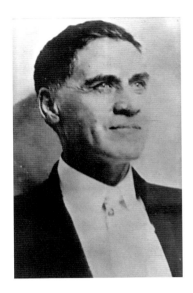

Police Chief S.W. Zickefoose planned to track the Majors gang by airplane but never got the chance. *Wichita Police Department.*

Chief S.W. Zickefoose was said to have had Dr. Queen under surveillance for the past year as the brains behind unspecified con games in Wichita. Shortly after the Benton robbery, Zickefoose somehow made the connection between Dr. Queen and the Majors Gang; one report said he'd heard Queen was trying to dispose of a large quantity of bonds in Denver. Zickefoose put two undercover cops on his trail, and the U.S. Secret Service and other authorities were involved as well.

In the weeks leading up to his arrest, Dr. Queen reportedly traveled to Pennsylvania, Minnesota, Colorado and Tennessee, as authorities lost and re-found his trail. Two days before Queen's arrest, Zickefoose notified the U.S. Secret Service that Queen would be traveling by train from Wichita to Memphis to meet other gang members.

Meanwhile, police and Pinkerton detectives followed tips regarding the whereabouts of Walter Majors. On the night of September 21, they surrounded a suite in the Windemere Hotel in St. Louis. Bursting in, the officers found the wounded Majors and a female companion. Two loaded shotguns lay nearby. Majors was either too weak or surprised to resist. Police found $1,200 in the sole of a shoe of the woman.

In Kansas City the next year, the Majors brothers and Adams each went on trial individually for the murder of the gambler Frank Gardner. Ray Majors was represented by attorney Jesse James Jr. (the son of the outlaw). James conceded that his client was guilty of robbery and shooting police officers but not of killing Gardner. Jurors disagreed. "Oh my boy—my boy!" Majors's mother sobbed as he was led out of the courtroom, staring straight ahead. His brother and Adams were also found guilty.

The Majors brothers were sent to prison in Jefferson City, Missouri, to begin serving life terms, but Adams had other plans. As he was being transported with the Majors and other felons, Adams managed to throw himself through a window of a moving train, despite being shackled and surrounded by armed guards. A search of the area made it clear that he'd survived the leap and gotten away.

Neither Eddie Adams nor the Majors brothers sought leniency in exchange for turning state's evidence. The same can't be said for the rest of the gang. In El Dorado, George Brown pleaded guilty to taking part in the Benton State Bank robbery and testified against the Poffenbergers. Brown got ten to twenty-one years in the pen and was made a trusty in recognition of his cooperation with the investigation. Brown, an expert electrician, escaped in August of that year after being sent outside the prison walls to repair a telephone line.

Major "Fat" Poffenberger cooperated with the investigation, jumped bail and fled to Canada. He was captured, waived extradition and eventually pleaded guilty to the Benton robbery. "Doc" Queen maintained his innocence. He told the *Eagle* that Major Poffenberger falsely implicated him while seeking immunity for himself. Wichita police, Queen claimed, had been after him ever since he'd been acquitted in the old bootlegging case. "If the police force would spend half the energy and effort in catching the thugs that are holding up citizens in the city almost nightly, as they have spent in attempting to get something against me, Wichita would not have the name over the outside world of harboring a den of thieves and bank robbers," Queen told a newspaper reporter. Even so, Queen worded his denials in such a way that raised questions, as when he said police "will never find where I sold, or in any way handled the loot."

No formal charges resulted from Queen's Memphis arrest. But in May 1920, he was arrested again, this time in Kansas, on a charge of complicity in the February 7, 1919 robbery of $50,000 in bonds from the Buhler State Bank. A private detective named Jack Hay, apparently working for the bank or its insurer, claimed credit for luring Queen back to Wichita, where Hay detained him at the Lassen Hotel until police arrived. The surprised Queen was nicely dressed, as usual, but appeared depressed and in failing health.

An unnamed federal agent intimated that Queen was providing the state with evidence against fellow gang members in exchange for leniency. "I wouldn't give two cents for Doc Queen's life," the agent said, speculating that the doctor would be dead within a year. "There are too many on his trail."

The federal agent's prediction wasn't far off, although Queen's death was due to natural causes. Queen's wife had moved to Asheville, North Carolina, with two of their children, who were suffering from tuberculosis, before the bank charges against her husband surfaced. Queen himself died there of chronic heart inflammation in 1924, a year before the deaths of Emerson and another son.

The gang's leader, Walter Majors, died of spinal meningitis in June 1920, two months after entering prison. He was twenty-four. A sister from Fort Worth, Texas, claimed his body and had it taken to Wichita for burial. Contacted by the *Beacon*, Majors's sister emphatically denied that he was the same Walter Majors who robbed banks.

THE ROTARY AND
THE WOBBLIES

Keeping a man in the rotary is the same as keeping him in a toilet.
—*District Judge Richard Bird on the Sedgwick County "rotary" jail,
from the* Eagle, *November 2, 1919*

When an inmate named Stephen Shuren learned he'd have to spend another five months in the Sedgwick County Jail in 1918, he walked back to his cell, took out his razor blade and cut his throat from ear to ear. Such was the reaction that incarceration in Wichita's primary lockup could provoke during that era.

Jails in the late 1800s and early 1900s weren't known for their plush accommodations any more than are those of today. What made the Sedgwick County Jail worse than most was the "rotary." Describing the rotary today almost invites disbelief. It consisted of a giant circular steel cage divided into two levels of twelve cells each. The whole thing was designed to spin around a central shaft like a carousel courtesy of a hand crank that could be operated (at least in theory) by one man. There was a single door leading in and out of the cells on each level. Like the guillotine, whose inventor sought to make capital punishment more humane, the rotary jail was a supposedly innovative concept in criminal justice that went horribly wrong.

According to one historian, about seventeen to eighteen rotary jails were built in the United States between 1881 and 1890, most by the Pauly Jail Building and Manufacturing Company of St. Louis. Sedgwick County paid Pauly $47,225 in 1888 to build a rotary jail, prompting the *Eagle* to

Sedgwick County's second jail housed bizarre "rotary" cells. *Sedgwick County Sheriff's Office.*

rhapsodize that the county "will have a jail building superior to anything in the state and in keeping with the wide-awake and enterprising city of Wichita." "No better or more scientific jail is built in the United States," the paper added later that year.

The idea of a rotary jail was seemingly first brought to the county's attention via a letter to the *Eagle* from a landscape gardener from New Hampshire named A. Ellis. He was moving to Wichita soon and thought that his future home, the "Peerless City," should know about this great concept. Ellis can perhaps be forgiven his enthusiasm only because he went on to create the beautiful Maple Grove Cemetery on Hillside Avenue.

From the county's perspective, the rotary must have seemed like a good investment. It took fewer employees to watch two cell doors than twenty-four, so the potential savings in manpower were obvious. Rotary jails were touted as escape proof, since an inmate who succeeded in somehow breaking through his own cell bars would then encounter an outer circle of bars.

The county's first clue that its new jail had operational issues came when it was just a year old. First, jail engineer James Potts had his hand crushed and lost a finger in the cogs of the rotary while trying to adjust its gears. Then

it was discovered that friction wore away the iron roller that the cells turned on. That roller was replaced with one made of steel.

From the inmates' perspective, gears and rollers weren't the only problem. The pie-shaped cells were each separated by a solid steel panel, making a stay the equivalent of solitary confinement. There was no artificial lighting, and the rotary sat too far from windows in the outer brick walls to get much natural light. Each cell in the rotary contained its own toilet, which might have been convenient for occupants except for the county's reluctance to maintain or clean them.

The jailhouse held several traditional (that is, non-moving) cells. It's clear that being assigned to a rotary cell was a disciplinary measure and perhaps a way to soften up uncooperative inmates. "Humphrey is put into a Rotary Cell for Punishment," reads an *Eagle* headline in 1895. The same year, a "little boy" was locked in the rotary "for stealing a pair of shoes." In 1907, a jailer named Pulliam "placed the six negro county prisoners in the rotary cell because they have not been acting as they should lately."

Irene and Norvel Williamson, the mother-and-son team of accused murderers we met earlier, certainly were not fans of the rotary. "I was only shut up in the rotary a few hours and it almost drove me wild," Mrs. Williamson told a journalist. Neither was radical prohibitionist Carry Nation, who was moved there from a regular cell after she became "abusive to the sheriff's wife…and called her all sorts of names." Nation, in a letter to a Topeka newspaper, called it "a place of torture." In 1896, an inmate reported seeing a ghost in the rotary. That couldn't be verified, but cohabitation with large rats was an accepted fact.

The rotary had been touted as escape proof, but in 1899 seven men proved otherwise. The instigator, a horse thief named Bill Tackett, sawed his way out after being housed in the cell turned to the rotary's sole opening. The effort left him so exhausted that he couldn't bend the bars on the window of the jail's outer wall. Tackett turned the rotary around to set other inmates free, threatening them with a wooden gun if they wouldn't help. They did, although most except Tackett were soon captured.

That same year, a health inspector named Dr. Shultz discovered that inmates in the rotary had been drinking contaminated water from a large, uncovered holding tank suspended over the cells. Dust coming in from open windows had settled in the tank for years; it was unknown when, if ever, it had been cleaned. "That water," Dr. Shultz said, "is not fit for a hog to wallow in, and yet you are penning men"—and women, he might have added—"in the county jail and compelling them to drink it. It is absolutely

dangerous, and is likely to kill every one of them and curse the city with some contagious disease." Traditional stationary water lines couldn't be used in the rotary because of how it turned. The county commissioners were "greatly agitated" over Shultz's discovery and agreed that something must be done.

The idea that the rotary might be a deathtrap in case of fire seems to have first been considered (at least publicly) in 1902, when it broke down and could only be turned backward, slowly, by the combined strength of three men. "How can a man ever get out?" one inmate asked. Although the brick jail building itself was unlikely to catch fire, it took less than that to place inmates in grave danger. In the spring of 1915, a trash fire in the basement of the jail "smoked up" and "nearly suffocated" a dozen men in the rotary. Inmates managed to break out windows on the walls opposite their cells to keep from asphyxiating, while two prisoners housed directly over the fire "were forced to dance the fox trot in order to keep the iron floor from blistering their feet." In 1917, the rotary completely broke down again while each cell held two men. One unfortunate inmate had posted bail but still could not be freed from the contraption. "If the building should catch fire and burn, he and his fellow jailmates would have to burn with it, for they cannot be let out," the *Eagle* reported.

Various inspectors condemned the rotary and jail as a whole, but the county could not find money to build a new one. "This is the worst jail in the country," longtime jailer "Daddy" Green told a group of students from Friends University who toured the facility in 1917. And soon the whole country knew it.

The rotary jail went from being a local scandal to a national embarrassment due to the incarceration of defendants in a controversial federal case. The men were members of the radical International Workers of the World organization. They had been arrested in 1917 for allegedly conspiring to disrupt production in the Mid-Continent oil fields around El Dorado and Augusta, supposedly as part of a plot to hinder the U.S. effort against Germany in World War I. The IWW's defenders argued that they were actually being persecuted on behalf of big oil companies and that their only crime was trying to recruit members in the oil fields. Judging from headlines in Kansas newspapers, community sentiment was all in favor of the government. The nation was involved in its first world war, and any threat had to be handled drastically.

On December 17 of that year, more than thirty IWW members—better known as "Wobblies"—were transferred from Butler County to Wichita. Their bail was set at $7,500 each, which none of the working-class defendants could make, meaning they'd be in the squalid jail at least until the next session of the federal grand jury was convened in March 1918. In reality, most would be in jail much longer.

That March, the grand jury indicted thirty-five men in the case. Still unable to make bail, the men were kept in the Sedgwick County Jail to await the next term of court, which didn't take place until September. Although the defendants possibly could have asked for and received a trial that spring, neither their attorneys nor federal prosecutors were anxious to proceed, though for different reasons.

The next delay in the case, however, was definitely the work of U.S. Attorney Fred Robertson. Worried that the first set of charges he'd drawn up would not hold, and without notifying defense attorneys, Robertson convened a second grand jury. When the IWW case was next called, in September 1918, Robertson surprised the defendants by filing a second, amended indictment against them. The IWW's attorneys, unwilling to go forward unprepared, asked for another delay. That's when Stephen Shuren tried to kill himself by slitting his throat. He survived but afterward had to be continually watched by his cellmates.

As a result of that delay, the IWW's defense attorney asked that his clients be moved out of the rotary—it "being old and unhygienic in appointments, and infested with a plague of rats." Judge John Pollock agreed to transfer some inmates to jails in Hutchinson, Newton and other Kansas towns but left eleven defendants in Sedgwick County's rotary jail.

The next month, those Wobblies in the Sedgwick County Jail began a propaganda campaign against it, focusing especially on the rotary cells. The leader was a short, wiry fifty-three-year-old named E.M. Boyd, who wrote to the National Civil Liberties Bureau (predecessor of the American Civil Liberties Union) about conditions in the place. Boyd reported

U.S. Attorney Fred Robertson. *U.S. Attorney's Office—District of Kansas.*

that one of the defendants, not coincidentally a native of Germany, had been kept for sixty-eight days in the rotary. "Cannot give you any idea of the filthy thing the 'rotary' is, and besides no one would believe it," Boyd wrote.

The rotary cells were seven feet long, measuring twenty inches across at the narrow end and six feet wide at the front, Boyd said. The noise made by the rotary when it turned was deafening, but the toilets were the biggest problem. They didn't flush automatically, instead requiring pails of water to wash excrement from troughs that ran under the cells. This was done about every two weeks—or whenever the guards couldn't stand the smell anymore. Another inmate penned an article for an IWW publication in which he said inmates were confined in the rotary for all but two hours a week, or just long enough to bathe and wash their clothes. The rats in the jail, he added, were as big as jackrabbits.

At the federal court's next session, in March 1919, lawyers chose a jury and the trial was about ready to begin when Judge Pollock announced yet another delay while he considered defense arguments in favor of throwing out the indictment. In May, he did just that. But the judge also "unofficially" offered U.S. Attorney Robertson advice on how to draw up a third and final version of the indictment that Robertson ultimately filed. Ironically, the defense's successful efforts to fight the charges increased the amount of time the defendants spent in the squalid jail.

The rotary jail particularly came to national attention after an investigative reporter named Winthrop B. Lane, hired by the National Civil Liberties Bureau, published his exposé about Kansas jails in the national magazine *Survey*. A Justice Department official acknowledged that "the jail at Wichita is unfit for an animal, let along human beings." Unfortunately, that article and admission didn't come until September 1919—nearly two years after IWW members were locked up there.

Federal judge John Pollock. *U.S. District Court—District of Kansas.*

In the wake of Lane's article, a lawyer for the IWW defendants argued that the upcoming trail should be moved out of Wichita. Judge Pollock, after appointing a three-member commission to investigate jail conditions and make a report, moved the defendants and their trial to Kansas City.

A number of factors conspired to keep the IWW inmates incarcerated in Wichita under inhumane conditions for so long. One was the attitude of U.S. Attorney Robertson, who was based in Topeka. Early on, Robertson privately acknowledged that he wasn't unduly worried about winning the case, seeing it "largely as a preventive measure to prevent possible violence in southern Kansas." The best way of doing that was to keep the men he thought most capable of inciting it in jail, guilty or not. Robertson treated the defense attorneys with contempt and kept some of the inmates from getting out on bail even after they'd raised the required money. The feeling of disgust was mutual. "We call him 'The Hog' as his resemblance to a prize Berkshire at a county fair is really quite pronounced," inmate Boyd wrote of Robertson.

The El Dorado and Augusta oil fields were then among the most productive in the world, and Robertson wasn't exaggerating when he said that petroleum was the most important raw ingredient in warfare. "It lubricates the wheels of industry, supplies gasoline as fuel for airplanes, kerosene for artificial lighting, fuel oil for torpedo-boat destroyers and battleships…is the emotive power in tanks, and is used in the manufacture of poison gas," Robertson wrote to a correspondent.

However, after the war's end in November 1918 and the appointment of a new U.S. attorney general as Robertson's boss, the Wichita IWW case seems to have been viewed differently by Justice Department officials in Washington. One said it "has been handled very badly by our District Attorney….We have to admit that it looks pretty bad to hold men in jail principally because the Government's attorneys are not capable of drawing a good indictment." On the other hand, some IWW leaders believed that keeping members jailed under such atrocious conditions had propaganda value.

In December 1919, the IWW defendants were all convicted in Kansas City and sent to prison. They sang "La Marseillaise" as they marched into the penitentiary in Leavenworth. Most were released less than two years later, due to a higher court's ruling that part of the conviction was flawed. One researcher who has studied the case extensively believes that Judge Pollock actually intended for that to happen. Pollock was viewed as sympathetic to "the little man" and generally had a standing rule against delaying trials when defendants were financially incapable of posting bail.

What was the net effect on the men who spent so long in the Sedgwick County Jail? The suicidal Shuren and one other inmate were eventually sent to the state mental hospital in Osawatomie. Several others claimed

that the jail permanently damaged their lungs or eyesight; the evidence is inconclusive.

Thanks to the IWW case, the Sedgwick County Jail continued to be a black mark on Wichita's reputation even after the rotary had finally been put out of commission. In 1922, the American Civil Liberties Union published a pamphlet about the IWW case calling Sedgwick County's Jail one of the filthiest in the country and bemoaning the "almost incredible conditions" there. It was endorsed by the ACLU's national committee at the time, which was made up of such luminaries as Jane Addams, Felix Frankfurter and Helen Keller. Another publication wrongly claimed that one defendant had died in the jail. In fact, he died of influenza after being moved to the Newton jail.

The rotary cells, so often called unfit for humans, found another use after the jail was torn down in 1924. They were moved to the old Wichita zoo in Riverside Park to house animals.

CLEVER EDDIE

When last seen, Eddie Adams was leaping through the window of a train taking him to prison in Jefferson City, Missouri, for the murder of Kansas City gambler Frank Gardner. Although it couldn't have been predicted then, he went on to wreak more criminal havoc than anyone in Wichita's first one hundred years.

Adams managed to escape from the prison train while shackled to eleven fellow prisoners in a car watched by seven guards. It took authorities several months to figure out how he did it. They concluded that one afternoon in March 1920, while Adams was confined in the top story of the Jackson County Courthouse in Kansas City, awaiting transport to Jefferson City, an accomplice made his way to the attic above him. This man walked to a corner where a drainpipe stretched from the roof to the basement. He poured acid around the pipe, softening the concrete in which it sat, and then slipped two thin steel saws and one bottle of acid through the cracks. Adams later used the acid to soften the metal in the bonds that held him and then cut through them with the saws. Exactly how he put them to use without arousing suspicion was not known.

Adam's diminutive size—about five feet, seven inches and 135 pounds—earned him one nickname: "Little Eddie." His knack for eluding captors garnered him another: "Clever Eddie." When not in prison garb, Adams was a sharp dresser who cut his hair in a style that made him look about twenty-one years old, although he actually was in his early thirties.

In this re-creation of Eddie Adams's last shootout with police by the *Beacon*, Adams lies on the ground with his gun pointed upward. Fatally wounded officer Charles Hoffman is sprawled partly across Adams's legs. Officer Ed Bowman, also wounded, fires at Adams, while officer D.C. Stuckey takes aim from behind a pillar. *Wichita Public Library microfilm.*

Eddie Adams wasn't his real name. He'd been born J.W. Wallace in Hutchison and moved with his parents to Wichita when he was nearly grown, working for a while as a barber on East Douglas Avenue. (There's some dispute about this, with one report giving Adams's real name as Robert H. Graham. Other aliases he employed were H.W. Armstrong, Harry Graham and Bob Lang.) He went back to Hutchinson to marry an old sweetheart, but she threw him over for another suitor. Adams returned to Wichita a changed man—gambling, using drugs and running with the Majors Gang as perhaps its nerviest member.

Eleven months after his escape from the prison train, Adams was in custody again, though not for lack of trying. On the morning of February 21, 1921, Adams and another Wichitan, Julius Finney, robbed a bank and store in Cullison, Kansas, eighty-eight miles west of Wichita in Pratt County. Cullison residents sounded the alarm by telephone through towns along the way back to Wichita. Posses formed in Goddard and Garden Plain.

Just outside Garden Plain, five men blocked a bridge by parking a long sedan across the road. A short time later, a Buick sped around the bend and crashed into it. Finney was apprehended at once, fumbling for a pistol jarred from his pocket by the crash. Adams stepped from the wrecked Buick still clutching the steering wheel in his hands. He dropped it, grabbed his

pistol and ran as posse members fired at him. He darted into a field and headed north.

After taking Finney to jail in Pratt, the posse resumed its search for Adams, focusing on the area around a bridge about a mile from the crash. They looked in straw shacks and sheds and peered under the bridge but did not see Adams, who had crawled between two beams supporting the span. Adams held the uncomfortable position for a half hour before he lowered himself down for a stretch and was spotted by a member the search party. "Stick 'em up, kid," a deputy sheriff said, pushing the barrel of his shotgun into Adams's ribs. "I've got you." "For God's sake, don't shoot!" Adams replied.

Police found loot stolen from the Cullison bank, half a dozen dynamite caps and twenty feet of fuse in his clothing. Adams had buried his pistol, a Colt .45, at the end of the bridge. Adams also carried a two-ounce bottle of nitroglycerine in his coat, which had somehow not exploded in the powerful collision at the bridge.

For two weeks, Adams convinced the sheriff in Pratt County that he was somebody else. Ironically, he used his real named, J.W. Wallace, as an alias and gave his age as twenty-three. A Wichita policeman who'd seen a photograph of the captured man first guessed he was Adams, even though the photograph differed from one snapped of Adams after his arrest in Kansas City. Setting aside superficial differences, however, the prisoner's blue eyes, curly hair, convex profile and other facial features matched those of Adams. No less an authority on the Wichita underworld than John Callahan agreed that the man in the photograph was Adams.

Wichita police offered the Pratt County sheriff $500 for Adams. They may have had a motive beyond simply seeking justice: a $6,000 reward had been offered for Adams's capture by authorities in Kansas City. The sheriff refused to turn him over but did allow the Wichita police to summon a fingerprint expert from Kansas City to examine Adams. The prisoner finally gave up the ruse. "I may as well admit it to you, sheriff, I am Eddie Adams. 'Clever Eddie' they call me."

By now, the *Beacon* had taken to referring to Adams as "the real brains" of the Majors Gang, broken up eighteen months earlier. Adams wouldn't reveal what he'd been up to since his escape other than to say he'd avoided capture by doing most of his traveling at night. Police in the region attributed nearly a dozen jobs to Adams, including robberies of the Riverside Pharmacy in Wichita and State Bank of Howe, Nebraska.

Adams and Finney were tried and given sentences of ten to thirty years in the Pratt County robberies and sent to the Kansas state penitentiary at Lansing. Adams told a prosecutor he was wasting his effort. "I won't do time. As man to man, I tell you that you will lay up trouble for yourselves by sending me to the pen. I'll get out." Coming from anybody else, that may have sounded like an empty boast. But Adams spent only a few months in Lansing before he escaped again in what might have been his greatest feat of daring. On the night of August 14, Adams and a cellmate, a seventeen-year-old inmate named Frank Foster, sawed through the window bars of their cell, jumped to the roof of a nearby shed and made their way to the boiler room of the prison.

There they joined three other inmates who had made a ladder out of scrap wood. Adams and the others cut off power to the prison, leaving the entire institution in darkness, and then carried the ladder to the thirty-foot-high outer wall. All made it over except one, who fell back inside the prison yard while being shot at by guards. The escapees were last seen on railroad tracks leading to Kansas City, where they robbed a railroad agent of his clothing to cover up their prison garb.

In Wichita, a police captain predicted that Adams would be back within forty-eight hours, put together a gang and embark on another crime spree. Some officers believed that Adams would look to settle scores with certain members of the police force. A private detective voiced the opposite opinion, saying Adams was too well known to return.

The police proved right. Within days of Adams's escape from Lansing, police suspected his involvement in a number of Wichita-area crimes. One was the theft of a stash of guns and weapons, a car and men's clothing in Peabody, Kansas.

Adams's reputation as a criminal Houdini seemed to grow daily. The *Beacon* reported that the previous winter, while being hunted across the country by lawmen, Adams had strolled into the Wichita police station, visited with a pal who was in jail there and walked out again without being recognized. "The little banks, scattered throughout the rural sections of the country, shiver spasmodically, and lay by their six-shooters," the *Beacon* said. Certainly somebody seemed to be readying for action. Five thousand rounds of ammunition disappeared in one area heist.

During one week that September, three banks within a short radius of Wichita were robbed or broken into. Someone tunneled into the State Bank of Burdick, near Herington, swiping several hundred dollars in cash and securities kept in safety deposit boxes. Another $400 was taken from deposit boxes in the State Bank of Furley, although the robbers failed to smash their

way into a new, more secure safe holding several thousand more. Robbers met with similar resistance from a safe in Andover.

From Furley, in northeastern Sedgwick County, police followed the tracks of the suspected yeggman's car to a garage six miles north of Wichita. Despite speculation that Adams was responsible, at least one police detective doubted it. The one way to get into the new, more secure safes was with nitroglycerin—known as "soup" in the trade—and Adams was known to be handy with the stuff.

However, Adams and his gang had been active, almost frenetically so. They were later tied to robberies in Haysville, Rose Hill, Arlington (Reno County), Luray (Russell County), Portus (Osborne County), Quincy (Greenwood County) and Americus (Lyon County).

In late October, the Adams Gang stole a Hudson car in Wichita and drove to Iowa, killing a farmer and wounding three deputy sheriffs who tried to apprehend them. Adams crossed into northern Missouri, abandoned the Hudson and stole a Studebaker. He later exchanged that in Riley County, Kansas, for another stolen car, an Overland model, which is what he was he was driving when he shot a Harvey County deputy sheriff on October 22. The deputy survived.

Adams also was positively identified as the man who single-handedly robbed a mail train in Ottawa, Kansas, on November 5. He tied up a few postal clerks before jumping off the train at Zarah, Kansas. He was reported—after the fact, of course—to have spent the night of November 3 in the Lassen Hotel in Wichita, wearing only a hat and tortoise shell glasses as a disguise.

The confirmed reappearance of Adams that Wichita police had been dreading turned out even worse than anticipated. At about 1:20 a.m. on November 21, a Monday, two Wichita policemen in a motorcycle and sidecar pulled over a Buick with five people inside—two women and three men—at Hydraulic and Harry, suspicious that the driver was drunk or otherwise impaired.

The police recognized one of the men inside as George "Chub" McFarland, a meat cutter by trade who had previously been arrested (though not convicted) for selling illegal drugs. The driver of the Buick was directed to proceed to police headquarters. Because McFarland was known to officers and not considered dangerous, the officers did not search of the car or its inhabitants. That decision proved fatal.

After the Buick traveled a short distance west on Harry, a man in its back seat reached out and opened fire with a .38-caliber revolver on the

trailing cops. One bullet struck Patrolman Robert Fitzpatrick in the head. As the Buick sped away, Fitzpatrick rose up in the sidecar and then slumped against his partner. Fitzpatrick, who'd been on the force seven months, died almost instantly. He was a World War I veteran and the father of two young children.

The Buick raced into west Wichita, where the two women got out and the men headed south into Cowley County. At about 3:00 a.m., they pulled into the driveway of a sixty-year-old farmer named George Oldham some six miles west of Winfield, woke him and asked for gas. When the Buick wouldn't start, they told Oldham that they needed his vehicle. When he objected, they shot him in the neck.

Just about this time, the Cowley County sheriff and some other men drove up, spotted the Buick and exchanged gunfire with the bandits. The fugitives got away across some fields, finding another car to steal some three miles distant. Lawmen from Wichita, Sumner and Cowley Counties and from Oklahoma followed what they thought was the outlaws' trail to Newkirk, Okla. Instead, the bandits managed to double back to Wichita, eluding police in at least a dozen towns that were on the lookout for them.

At about ten o'clock that morning, a man fitting Eddie Adams's description got in a Dodge near Waco and Harry in south Wichita and drove off. A short time later, the same Dodge pulled in front of George McFarland's house at 1229 South Washington, inside of which two police officers had been stationed in case the outlaws returned.

Officer Ray Casner stood near the front door of the house as two men approached. As one of them opened the door, Casner pointed the shotgun at his head and pulled the trigger, apparently deciding to leave nothing to chance. The shotgun failed to fire. At about the same time, one of the men drew his revolver and shot Casner in the right hip.

Back in their car, the gunmen headed east, which shifted the direction of the manhunt in that direction. A Dodge containing men matching the description of the suspects was spotted speeding through Cassoday, north of El Dorado. With a good portion of Wichita's police force already diverted to the south, everybody from the city's fire chief to members of the Butler County Anti-Horse Thief Association joined the new search.

In all the confusion, a Wichita police officer mistook a carload of fellow officers, including Chief of Detectives (and former police chief) S.W. Zickefoose, for the bandits and opened fired on it, resulting in one officer losing part of a finger. The actual outlaws were thought to be headed toward Kansas City, or possibly Oklahoma.

But Adams and his gang, if they ever actually left Wichita, were back the next day, the Tuesday before Thanksgiving. Adams decided to pick up a fresh car from a rental service—using an alias, naturally. The first garage where Adams stopped refused to let him a have a rental. In fact, the owner telephoned police with his suspicion that one of the fugitive gunmen had just been in his place. Three police detectives—Charles Hoffman, Ed Bowman and D.C. Stuckey—hurried over to the garage. Adams was gone; he'd met up with a pal and headed east on Douglas. That Adams was willing to stroll through downtown Wichita while most of the lawmen in south-central Kansas were looking for him says something about his lack of fear.

The three detectives drove east as far as Washington Avenue trying to spot Adams and then backtracked to Union Station. It was there that Detective Stuckey recalled another business, Driverless Motor Livery at 306 South Lawrence, that also rented automobiles. By the time the trio reached that establishment, Adams was inside signing for a car. Adams, suddenly finding himself standing next to a detective, played it cool. "Your name is Hoffman, isn't it?" he said. The detective said it was and that he was there to see him. "You'll have to come back here if you want to see me," Adams said, taking a few steps toward the rear of the garage.

Hoffman was known for his aversion to using deadly force on suspects, no matter how dangerous they were. He preferred to bring them in with persuasion or his bare hands. As the other two detectives looked on, Adams made a sudden move, and Hoffman grabbed him by the neck. The two wrestled fiercely. Adams managed to place his revolver against the policeman's stomach and pull the trigger. "My God, I'm shot," the detective cried.

Adams also got off several close-range shots at Bowman, hitting him twice. In return, Bowman pointed his Colt automatic at Adams's head and fired. At nearly the same instant, Stuckey, who'd taken cover behind a pillar, aimed a shot at Adams's head, his bullet apparently passing through Adams's right cheek and jaw.

Adams and Hoffman both fell to the ground, the wounded detective across the wounded outlaw's legs. Bowman leaned over Adams, thinking him dead. The bandit raised his gun once more and fired, this shot grazing Bowman's nose and leaving power burns across his face. Only then did Eddie Adams die.

An estimated seven to ten thousand people viewed Eddie Adams's body as it lay in the City Undertaking Parlor. By comparison, four thousand came to see the corpse of John Dillinger, America's "Public Enemy No. 1," when he was killed in Chicago in 1934.

In the hospital, Detective Hoffman asked Zickefoose who shot him. Zickefoose told him it was Eddie Adams. "I thought so," Hoffman said. Hoffman died the day after Thanksgiving. Officers Bowman and Casner recovered. It in no way decreases Adams's villainy to say that he probably wasn't responsible for murdering two other Wichita policemen—as is commonly believed—or of attempting to kill a third. On November 4 of that year, Officer A.L. Young had been shot and killed shortly after getting off a streetcar at Eleventh Street and Bitting in the Riverside neighborhood. Frank Foster—the teen who'd escaped from Lansing with Adams—later claimed that Adams had shot Young because the two were "paying court" to the same women. At the time of his statement, Foster was under arrest for murder. No other evidence links Adams to the crime.

Adams also did not fire the shot that killed the motorcycle officer Fitzpatrick, although he was in the car from which the bullet was fired, apparently asleep or in a drug-induced stupor. Rather, it's believed that Foster or George McFarland did so. And despite initial reports that Adams wounded Officer Casner at McFarland's house, the officer himself said it was somebody else. Wichita police rounded up more than three dozen suspected criminals following the shootout. McFarland was arrested after being overheard muttering in his sleep at a railroad station in Cowley County. "Why did I go with those fellows?" the station agent heard him say.

Although it had been speculated that no local minister would willingly conduct a funeral for Adams, Reverend E.M. Smith, pastor of a church on Harry Street, volunteered, saying every man deserves a decent burial and that it would be a good opportunity to preach against the wages of sin. To raise money for the slain officers' families, police made plans to display Adams's gun and other items related to the case at the Forum auditorium and charge admission.

In Wichita, the two major newspapers generally agreed on little. But in the wake of Eddie Adams's reign of terror, they were of one voice about the city's propensity for tolerating criminal activity. Citizens "should insist that the whole underworld should be run out of town," the *Beacon* said in a front-page editorial. "Wichita is too small to have an underworld. It will still be too small if it reaches a million population." The factors that created the underworld, the *Beacon* said, were "propaganda" against police for using their weapons; professional bondsmen willing to help "disreputable characters"; lawyers "who have fattened off the business of defending criminals"; courts being too lenient in setting bonds and

sentences; a proliferation of concealed weapons; and "a large number of dope-fiends who have been handled leniently."

The *Eagle* added the police department to those deserving blame. Adams, after his escape from Lansing, "was a familiar figure on our streets, known to all who know the underworld." The city's "excellent" chief of detectives "could not be so stupid and so ill informed…as to be unable to recognize Eddie Adams.…There was little crime in Wichita while Eddie Adams was at the head of our criminal world, but there was much crime outside of Wichita. Eddie and his gang went out and robbed banks and mail trains, and then retreated to the safety of their Wichita haunts, where they were unmolested."

The devil's bargain had ended tragically. As the newspaper said, "A city cannot harbor desperate criminals without reaping the whirlwind thus sown."

KU KLUX KANSAS

*E*arly one evening in November 1922, two taxicabs disgorged an unusual set of passengers at Wesley Hospital. They were a half dozen members of the Ku Klux Klan, arriving for an appointment with hospital officials. Four of the men wore the Klan's customary white robes, their hoods pushed back to reveal their faces. The other two wore business suits.

After making their way to a conference room, they were met by a trio of hospital officials: the president of the hospital's board, its assistant superintendent and the chair of its fundraising campaign. One of the Klansmen handed an envelope to the board president, W.M.G. Howse. It contained a check for $8,160, intended to help with the hospital's goal of erasing a $300,000 debt. Call it a kinder, gentler Klan.

Except that before the Klansmen handed over the money, a spokesman gave a speech about the "cloud of misrepresentation" surrounding the KKK and explaining its "real ideals and aims." The Klan limited its membership to American-born white people, the spokesman explained, not because it hated foreigners, but only because it "had to draw the line somewhere." The KKK did not hate Jews, he said, but could not allow them as members because of its dedication to Jesus Christ. Catholics were shunned similarly because of their fondness for parochial schools and allegiance to a foreign leader, the pope. On the subject of black Americans—the victims of so many Klan lynchings elsewhere—the local spokesman declared that the KKK "is the Negro's real friend." And

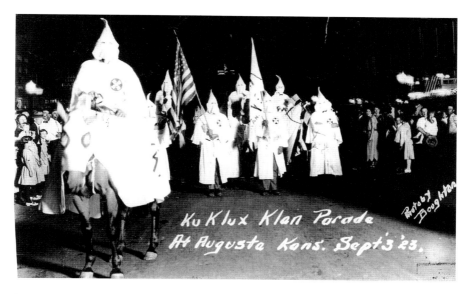

Ku Klux Klan members march in Augusta, Kansas. Klansmen from Wichita and surrounding towns donated money to Wesley Hospital in 1922. *Augusta Historical Museum.*

that's because the white race was the only one that had ever ruled wisely and justly.

Wesley's president, Mr. Howse, was so overcome with gratitude that he claimed words almost failed him. "The supreme loyalty which your speech has manifested, the charity and breadth, the absence of malice, all are different from the common conception of your order and prove that you are working for the good of mankind. Your gift has come at a time when you have saved the institution." The Klansmen bowed and withdrew.

Wesley's decision to accept Klan money met with some public criticism, but not all that much, and President Howse stood by his decision. The Klan was well established in Wichita and other parts of Kansas at that time, part of its nationwide resurgence. Estimates of the organization's peak membership in Wichita range from about one thousand to six thousand members. At the time of the Wesley donation, one Klansman said members had each contributed a dollar. A tally sheet given to the hospital by the KKK showed that $4,235 of the donation came from Wichita, with the rest raised in other Kansas towns.

As even its critics noted, the Klan in Kansas did not generally use violence to achieve its goal. Instead, it focused on controlling economic, political and

social institutions. In that respect, it differed from the KKK that sprang up after Reconstruction to terrorize black communities in the South. Nevertheless, that such an organization existed at all still amazes and offends many Wichitans.

Kansas's identity as a state was forged in the Civil War era. It's not a coincidence that a painting of radical abolitionist John Brown hangs in the state capitol or that the University of Kansas mascot is the Jayhawk, a name originally referring to antislavery Kansans who fought proslavery residents from Missouri. But despite the state's strong pro-Union stance during the Civil War, there were plenty of Wichitans willing to assign some of their fellow citizens a secondary status in the years that followed.

Black citizens had lived in Wichita since its beginnings. One of the best-known black residents, Samuel Jones, moved to Wichita with his family as a seven-year-old in 1874, when cattle were still driven up Douglas Avenue along what was known as the Chisholm Trail. The first black person to attend public school in Wichita, Jones shined shoes and ran errands for some of the city's working girls to make money as a child, taking messages to Emil Warner's beer garden and receiving a quarter tip in return. He joined the city's first black band as a cymbal player and then learned trombone and toured the country with a professional group for several years, punctuating the shows with acrobatics.

Back in Wichita, Jones worked as a printer and then was elected a county constable in the late 1880s, the first black person to hold public office here. At the same time, he launched a newspaper, the *National Baptist World*, an eight-page sheet he peddled for two cents. The *Eagle*, paying tribute to Jones's diverse abilities, wrote that it's "not often that a constable is imbued with a deep religious sentiment, but Sam is an exception. He can drop the editorial pen at any hour of the day, buckle up his six-shooter, give chase to a chicken thief, and return to the glories of the Baptist faith without the least disturbance in the realm of his thought." Jones also was the city's first black policeman, although he was only allowed to arrest other black people.

Jones and many other black Wichitans felt an intense patriotism for their country. Nevertheless, they had to beg to serve it. When the Spanish-American War broke out in 1898, two of Jones's friends immediately tried to enlist but were refused by the local recruiting officer. Jones's friends urged him to write an article for the *Eagle* or *Beacon* (where it would be read by whites) asking why "they, as colored men, should be denied the privilege of serving their country."

Jones counseled patience instead. He proved right when a new call for volunteers came a few days later, and Kansas's governor authorized Jones's friend to raise a regiment. The Wichita regiment made it to Cuba, where Jones, its commander, earned the nickname "Cap" by which he was known in Wichita. He lived in Wichita until a few years before his death, in 1960 at age ninety-three, an admired figure who'd served as city historian.

A common view of Wichita history is that race relations were generally good during the city's early decades, partly because the size of the black population was so small. It was only as that segment increased that racial tension increased. However, Brent Campney, author of *This Is Not Dixie: Racist Violence in Kansas*, casts serious doubt on that characterization. For instance, while most histories assert that no black citizens were ever lynched in Wichita, Campney believes that one extrajudicial killing qualifies.

In 1874—the same year Sam Jones's family moved to Wichita—a black man named Charley Sanders was working alongside some masons on Main Street when a white Texan stepped up and shot him dead. A dozen more Texans pulled their guns to keep anyone from intervening. The Texans then jumped on their horses and fled across the Arkansas River into Delano, giving a Rebel war yell as they went. A large, sympathetic crowd followed. The *Eagle* called the shooting a "cowardly…preconcerted murder" and demanded prosecution of the shooter and his accomplices. None was ever undertaken.

Campney makes the case that the killing was part of longer pattern of race-related trouble in Wichita. He records four "threatened" lynchings in Wichita between 1888 and 1906. The number "belies the notion of generally amiable race relations there." Even though no one was killed, the incidents "enforced white supremacy and elevated black fear."

In response, African Americans in Wichita and elsewhere mounted what became known as courthouse defenses of men accused of crimes. On a Saturday night in May 1888, for instance, a number of white residents were overheard plotting to lynch a black man named Tom Collins, who was held in the Sedgwick County Jail on a charge of raping a white woman. To help protect Collins, a group of black men gathered at the jail both Saturday and Sunday night. The *Beacon* chose to give most of the credit for preventing a

lynching that night to Sheriff W.W. Hays, saying that African Americans "had better not gather in any numbers about that place again" or they would risk igniting a "battle between the races."

Wichita's African Americans decided that was a risk worth taking, mounting similar courthouse defenses in 1901 and 1906, according to Campney. The *Topeka Plaindealer*, an African American newspaper, said that Wichita's black citizens "are to be congratulated that they are making a bold effort to protect life, liberty and property."

In 1893, black residents protested after police officer Harry Sutton fatally shot a black barber named Henry Aiken, whom he'd found in a white woman's house. Sutton, claiming Aiken attacked him, was acquitted of second-degree murder. In 1907, Wichita was thrown into an uproar when a black policeman tried to arrest a white man, apparently injuring him in the process. A vigilance committee of whites quickly formed, only to be met by about three hundred black Wichitans gathered in the packinghouse district. The latter were said to be "armed and boisterous."

Then there were the everyday humiliations. The *Wichita Globe*, a short-lived African American newspaper, reported in 1887 that a "prominent colored gentleman" tried to patronize a "little 2 x 4 restaurant" only to be told, "We don't allow colored men to eat here." One decade later, another of the city's African American papers, the *Wichita National Reflector*, remarked on the same tendency of operators of "one horse, 5-cent lunch counters." "It is the same old story of prejudice which appears to increase among a certain class of low-bred whites."

Wichita transformed itself into a segregated society during its first few decades. Initially, black residences were scattered about evenly between the northwest, northeast and south sides of the city. Black children such as Sam Jones attended school with white children, although few went beyond the eighth grade. In 1912, 13 of 1,011 students in Wichita's high school were black.

During the 1880s and 1890s, black homes became increasingly concentrated in the city's near northeast and northwest sections. Meanwhile, sentiment among some whites began to favor segregating the schools. Concerned Wichita black residents, led by a barber named O.L. Boyd, convinced state Senator O.H. Bentley to sponsor legislation in 1889 keeping Wichita from segregating its schools. That same year, the Wichita school district began buying single desks for its elementary schools instead of the traditional double ones so that black and white students would not sit next to each other.

Two years later, more concerned than ever about the drift toward segregation, black Wichitans met at St. Paul's African Methodist Episcopal Church to pass a resolution opposing it. In 1893, however, Boyd came out in favor of segregated schools. Black students were more likely to learn if taught by black teachers, and white parents would never allow the latter to teach their children, he argued. Black taxpayers had a right to have black educators hired in proportion to their population, he added. Another meeting was quickly convened at St. Paul's, where black leaders such as Jacob McAfee denounced segregation and labeled Boyd a traitor to his race.

In 1906, the Wichita School Board approved the creation of separate schools for white and black students, saying that the move was "in keeping with the ideals and wishes of a majority of patrons." Black leaders appeared before the board in protest, saying they represented at least two-thirds of black patrons, but it was to no avail. Thus began the segregation of Wichita schools that was not finally abolished until 1971.*

The Klan started recruiting members in Wichita and other Kansas cities in 1921. In December 1922, the *Eagle* reported that members met each Thursday at 125–27 South Lawrence (now Broadway), while the chief recruiter, an Oklahoman, stayed in room 511 of the Broadview Hotel when in town. A druggist was said to be the local Klan's treasurer, while a former southerner served as "grand cyclops," the top local post. The druggist, contacted by the *Eagle*, denied any involvement with the group. The newspaper noted that secrecy was one of the Klan's chef tenets.

The Wichita KKK—known as the Wichita Klan No. 6—was never accused of committing any violence or threatening to do so and, in fact, seems to have led a dysfunctional, comical existence. In 1924, the secretary of the Wichita Klan quarreled with the group's Atlanta headquarters over who should control $18,000 in membership fees. In 1926, some female members comprising a kind of KKK ladies' auxiliary became embroiled in a disagreement among themselves, also over money. In 1925, a team

* Segregation spread to other parts of the city as well, although there were white as well as black citizens opposed. In 1908, the manager of Wonderland amusement park refused admission to a black woman named Nannie Jones. A jury awarded Jones $400 after she sued Wonderland and two of its owners.

of Klansmen played a baseball game against a local all-black team called the Morovians at Wichita's Island Park ballfield. The Klan team lost.

Nevertheless, the organization's ability to sow hatred and discord was plain. "Too long have the liberty-loving, sacrificing, Protestant-Americans suffered at the hands of Kike and Catholic, and we are going to put an end to it," the group's "grand cyclops" said during a speech at the South Lawrence headquarters on November 23, 1922. "Peacefully, if you will permit it. But if not...then we are going to end it."

If there's a bright spot in the story of the Klan's time in Wichita, it's that Governor Henry Allen—publisher of the *Beacon* since 1908—began the effort that eventually led to the group's removal

Henry Allen, *Beacon* publisher and Kansas governor who battled the KKK. *Wichita–Sedgwick County Historical Museum.*

from Kansas. Allen took action after the Klan announced plans to hold its first parade in the state, in Arkansas City in 1922. Allen issued an executive order prohibiting the wearing of masks on Kansas streets.

When the Klan continued trying to intimidate Kansans—including kidnapping the Catholic mayor of Liberal—Allen launched investigations and, eventually, legal action against it. Federal agents helped in the investigation of the Wichita Klan by standing outside the Lawrence Avenue headquarters and compiling a "long list" of Wichitans who attended meetings there. They discovered the password was "potok."

Allen, in a speech, said he doubted whether most Kansas KKK members approved of violence. But if they were really just members of a Christian organization, he said, "Do they have to be masked to stand for that?" Just how popular Allen's crusade against the Klan was is open to interpretation. He did not run for reelection in 1922. His Republican Party lost the governorship to a Democrat who did not discourage Klan support.

THE PRINCE OF WICHITA

After so much banditry, bloodshed, bigotry and other seriously bad behavior, we end with the story of a man whose only crime was pretending to be somebody else. Well, there might have been a few misdemeanors to our protagonist's credit, but even his victims admitted he was charming. After all, how often does a Russian prince named Michael Alexandrovitch Dmitry Obolensky Romanoff show up in Wichita?

Prince Dmitry was short and slender, with wavy black hair, thick black eyebrows and voluptuous lips. His accent was English rather than Russian, owing to his education at Eton and Oxford. He dressed in riding breeches, short coat and derby hat. He appeared to be in his early thirties. He worked as a menial laborer. The prince's poverty merely contributed to the sense of glamour and mystery that surrounded him. After all, everyone knew that his family—the Romanoffs—had been all but wiped out by Russian revolutionaries a few years earlier through the infamous massacre of the last czar, Nicholas, and his immediate family. How had Prince Dmitry escaped? What privations had he endured?

A wealthy Wichita oil lawyer lent the prince money and welcomed him into his home, perhaps hoping to marry one of his two daughters into nobility. Dmitry was recruited onto the city's polo team for a match held up the road in Cassoday. Despite his elevated status, the prince didn't put on airs. He was, he said, a democrat with a small "d" and wished to be treated like everyone else in Wichita. Indeed, he'd taken a job as a common

laborer, working alongside a crew of African American street maintenance workers by day. But there was one problem with the prince's riches-to-rags story. It wasn't true.

Dmitry first came to attention in Wichita in the summer of 1923 thanks to an editor and writer at the *Wichita Eagle* named Charles Driscoll. According to Driscoll, the paper's police reporter told him one night that "the cops were having great fun beating and badgering" a man claiming to be a Russian prince.

Driscoll was a Wichita native who achieved some success at newspapers in St. Paul, Minnesota, and New York before returning home. He was as cynical as the typical newsroom veteran. In his view, the Murdock family, publishers of the *Eagle*, were more concerned with profits than putting out a good newspaper. Henry Allen, publisher of the *Beacon* and a two-term governor, was a little too fond of drink. And Sam Amidon, the city's most prominent attorney, was a grandstanding blowhard. But motivated by genuine concern or the desire for a good story, Driscoll took up the prince's case. Driscoll charged that Wichita police—led by Chief Detective S.W. Zickefoose—were harassing Dmitry because they believed he had hidden away a valuable cache of "Crown jewels" somewhere. Zickefoose, on the other hand, said the prince had been held for investigation of trying to pass a bad check, although it turned out the check was good.

Released from custody, Dmitry became a regular at Driscoll's office at the *Eagle*. The editor took him home for dinner and bought him meals at downtown restaurants, enjoying his new friend's urbane conversation. He took to calling him "Mike."

In an unpublished manuscript written some years later, Driscoll claimed that he had discovered his friend's false identity mainly based on the fact that another Russian Prince Dmitry was known to be living in Paris and London at the time and seemed to have a better claim to the title. Confronted with that information, Driscoll wrote, Mike/Dmitry "admitted to me that he was not exactly that prince, but another one, closely related, and considered it a point of honor to keep his identify secret." For unexplained reasons, Driscoll did not let his readers know this while writing about Mike's comings and goings in Wichita.

The proprietor of the city's leading department store, A.W. Hinkel, gave Mike a twenty-five-dollar-per-week job as a floorwalker in the store, where he became an object of fascination to local women. Hinkel also lent him

money and made him a member of the Wichita Club, a private men's club where he could live temporarily.

Mike played his part well. Once, for instance, Driscoll led him into a grocery store owned by a Russian to see if he could actually speak the language. Mike refused to be introduced to his fellow countryman, saying, "I wouldn't speak to that dirty *mujik*! His people killed my people and are responsible for most of my troubles." Driscoll thought the explanation "seemed logical enough."

However, further holes appeared in the prince's tale. As Driscoll's newspaper stories about him spread around the country, letters arrived from Hillsboro, Illinois, revealing that Mike had actually grown up there under the name of Harry Ferguson. He'd been sent there as a small boy by a New York society set up to take care of orphans.

Then letters arrived from New York City reporting that the Mike/Dmitry/Harry had escaped from Ellis Island on Christmas Day 1922 while being investigated for possible deportation. He had been sent there from England as an "undesirable." He claimed American birth, although he couldn't provide proof of it. Slipping out of the Ellis Island detention building, Mike swam at least one mile through icy water to New York's Battery district and then disappeared.

By now, Mike had made another friend in Wichita, a rich lumberman who let him stay in his apartment while the lumberman toured Europe. Driscoll visited him in the swanky Sedgwick Annex building (located at First and Market and at one time the largest office and apartment building in the state) several times, finding the prince too broke to buy ice to chill the lumberman's champagne. It was during one of these visits that Driscoll delivered some bad news: Wichita police had written Scotland Yard about Mike and received a reply in return detailing Mike's record of minor criminal offenses in England. The *Eagle*'s rival paper, the *Beacon*, planned to publish the story in its next edition, Driscoll said, which would surely lead to more police harassment. "But this is outrageous and preposterous!" Mike responded. "I suppose I must be off, else they'll be trying to deport me again. But how shall I go anywhere? I am devoid of funds."

As Driscoll predicted, the *Beacon* published its front-page story under the huge headline "'Prince' a Fake," complete with a mug shot of the prince taken in England. The *Beacon*, clearly relishing its scoop on the *Eagle*, noted that Mike had been "lionized" by local residents taken in by his act. The paper reported that Mike had once been sentenced to an insane asylum in England and quoted a newspaper editor in St. Louis (where Mike also ran

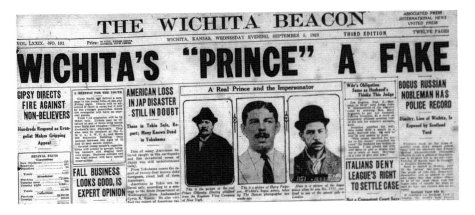

A *Beacon* headline exposed "Prince" Dmitri Romanoff as a fraud. *Wichita Public Library.*

into trouble) as saying, "He is a study in psychology and certainly one of the strangest cases of obsession that has come to my attention....He will convince a wooden Indian that his story is true."

Driscoll and the faux prince struck a bargain that would hopefully help both: the *Eagle* would buy Mike a train ticket to Chicago in exchange for him telling his full life story. With Driscoll typing, Mike proceeded to do so, and what a tale unfolded.

Mike claimed to be the secret love child of Alexander III—the Russian czar assassinated in 1894—and a Russian princess. He'd moved to New York with his mother, been shipped to Illinois by an orphans' society after her death and then made his way back to Russia. He'd attended college in England, fought with the Allies in World I and then battled the Bolsheviks during the Russian Revolution.

The *Eagle* article closed with his pathetic plea: "I have not cheated anybody. I have not hurt anybody....I have nothing to be ashamed of, but I had my own intimate secret, which, for the sake of others, I had hoped to keep. Even that I now give up to you. Will you not then let me live in peace and earn a scant living as Michael Dmitri, laborer?"

Driscoll gave Mike a train ticket to Chicago. The prince carried a trunk containing all his possessions to the station. He mentioned to Driscoll that he had no money for food. The editor proposed another deal. "You told me of a magazine article you have written, saying farewell to America and giving some impressions of the country. If it's readable, I'll give you fifteen dollars for it."

After some hesitation, Mike handed over the article, which Driscoll noticed had been neatly typed. The editor figured one of the women friends

the prince had made in Wichita had done it. The newspaper copyrighted and published the article a few days after Mike's departure. Months later, Driscoll discovered that the piece had been lifted word for word from an article by a famous English writer.

Mike continued to make use of his Wichita connection. After exhausting his meager bankroll in Chicago, he took a train to St. Paul (conning the conductor out of a ticket), where he tried to get a job with the newspaper by using Driscoll as a reference. That newspaper's editor instead got him a position translating Russian manuscripts at the St. Paul Public Library. The job ended with Mike refusing to do any work, saying that the material was badly written.

A wealthy lady gave Mike enough money to enroll in a special course in oil engineering at Harvard after he claimed to know where some large deposits were located. At Harvard, he gave an interview to the student newspaper, the *Crimson*, that was seen by his old benefactor Hinkel back in Wichita. The department store owner at once wrote to the *Crimson*'s editor exposing Mike as a fraud and demanding that the "prince" repay his small loan.

Mike's story wasn't over yet. In fact, the most amazing part was still to come. In 1932, the *New Yorker* magazine ran a celebrated series of profiles about him called "The Education of a Prince" that traced his actual life story. Mike had been born as Herschel Geguzin, the son of a Lithuanian dry goods merchant who died before he was born. Immigrating to the United States alone at age ten, he spent time in New York City orphanages and reform schools before being shipped to Illinois. As an adult, he'd bounced around the East Coast and Europe and was arrested numerous times for fraud before his arrival in Wichita.

The notoriety brought by the magazine stories was just a prelude to Mike's last and greatest role. In the 1940s, after making his way to Hollywood, he became the proprietor of Romanoff's restaurant, the hangout of movie stars. Never dropping his story of being a prince—despite the fact that nobody actually believed it—he became close friends with actors David Niven and Humphrey Bogart in addition to a popular figure in his own right, appearing on radio shows hosted by Jack Benny and Groucho Marx and later in films and television shows.

Meanwhile, Mike passed out of Wichita's collective memory. He died in 1971, nearly fifty years after his brief, strange sojourn in Wichita.

BIBLIOGRAPHY

The making of this book relied heavily on archived articles from local newspapers across Kansas and parts of Missouri, including the *Atchinson Daily Champion*, the *Coffeyville Daily Journal*, the *Evening Kansan-Republican* (Newton, KS), the *Fort Scott Daily Tribune*, the *Kansas City Journal*, the *Kansas City Journal of Commerce*, the *Lawrence Daily Journal*, the *Sabetha (KS) Herald*, the *Topeka Commonwealth*, the *Topeka Daily Capital*, the *Topeka State Journal*, the *Walnut Valley Times* (El Dorado, KS) and, of course, the *Wichita Beacon* and *Wichita Eagle*. They are available through the Kansas Historical Society website (kshs.org). In addition to these papers, the following sources were also consulted.

American Bankers Association Journal 12 (1919–20). Accessed online at books. google.com.

Bader, Robert Smith. *Prohibition in Kansas: A History*. Lawrence: University of Kansas Press, 1986.

Bentley, Orsemus H. *History of Wichita and Sedgwick County, Kansas*. 2 vols. Chicago: C.F. Cooper and Company, 1910.

Bunkowski, Lisa Miles. "The Butler County Kansas Vigilantes: An Examination of Violence and Community, 1870." University of Kansas, Department of History, 2003, abstract.

Campney, Brent M.S. *This Is Not Dixie: Racist Violence in Kansas*. Champaign: University of Illinois Press, 2015.

Cutler, William G. *History of the State of Kansas*. Chicago: A.T. Andreas, 1883.

Dash, Mike. "A Russian Prince on a Wichita Road Gang." A Blast from the Past, December 31, 2010. Mikedashhistory.com.

Driscoll, Charles B. "East and West of Wichita." Unpublished, undated manuscript.

Hathaway, Ann, and William J. Griffing. "Inez Griffing Becomes 'Dixie Lee'—Legendary Madam." Midwest Historical and Genealogical Society, 2004.

Kansas Supreme Court. *The State of Kansas v. Arthur Winner.* Decision, 1876. Accessed online.

———. *The State v. Frazier.* Opinion, 1895. Accessed online.

Miller, Nyle H., and Joseph W. Snell. *Why the West Was Wild: A Contemporary Look at the Antics of Some Highly Publicized Kansas Cowtown Personalities.* Topeka: Kansas Historical Society, 1963.

Miner, H. Craig. "Newton's General Massacre." Harvey County Historical Society.

———. "Nostrums and Quackery." Press of the American Medical Association, digitized 2007.

———. "Professor Samuels and His Eye Water." *Journal of the American Medical Association* (December 24, 1910). Accessed online.

———. *Wichita: The Early Years, 1865–80.* Lincoln: University of Nebraska Press, 1982.

Reynolds, John R. *The Twin Hells.* Chicago: Bee Publishing, 1890. Accessed online via kancoll.org.

Rhodes, Austin Charles. "Good Saloon, Bad Saloon: Saloons in Wichita, Kansas 1865–1881." Master's thesis, Department of History, Wichita State University, 2014.

Rosa, Joseph, and Waldo Koop. *Rowdy Joe Lowe: Gambler with a Gun.* Norman: University of Oklahoma Press, 2008.

School Desegregation in Wichita, Kansas. Staff report of the U.S. Commission on Civil Rights, 1977.

Sloan, Charles William, Jr. "Kansas Battles the Invisible Empire." Kansas Historical Society, 1974.

Supreme Court of Missouri. *State v. Majors* Ruling, 1922. Accessed online.

The Truth About the I.W.W. Prisoners. American Civil Liberties Union pamphlet, April 1922.

Von Meter, Sondra. "Black Resistance to Segregation in the Wichita Public Schools." 1870–1912." *Midwest Quarterly* (1978).

Wellman, Paul Iselin. *A Dynasty of Western Outlaws.* Lincoln: University of Nebraska Press, 1986.

White, Earl Bruce. "The Wichita Indictments and Trial of the Industrial Workers of the World, 1917–1919, and the Aftermath." PhD thesis, Department of History, University of Colorado, 1980.

Wrampe, Ann. "Wichita Township Soiled Doves." Wichita Local History Series, 1987.

ABOUT THE AUTHOR

*J*oe Stumpe is a writer and history buff whose work has appeared in the *Wichita Eagle*, *New York Times*, *Huffington Post* and many other publications across the country. *Wicked Wichita* is his first book. He lives in Wichita with his wife and chickens.